POSTCARD HISTORY SERIES

New York State Lighthouses

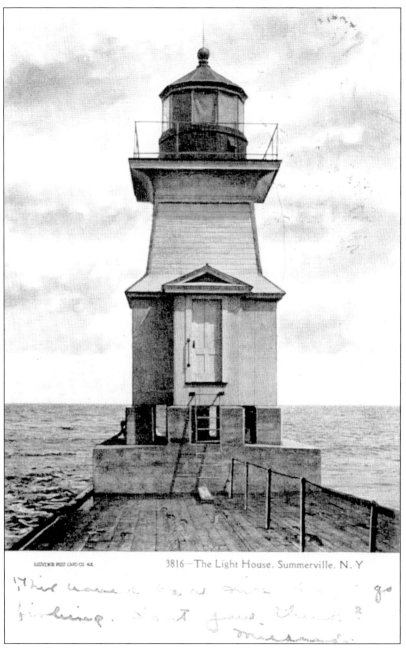

3816—The Light House, Summerville, N. Y

[handwritten note, illegible]

The Summerville Light, also known as the Genesee East Pier Light, was built in 1902. The square wooden tower stood on the east side of the entrance to Rochester Harbor, where the Genesee River meets Lake Ontario. Another light on the opposite pier had taken over the duties of the onshore Charlotte-Genesee Light 21 years earlier. The Summerville tower no longer stands.

On the front cover: The Summerville, or Genesee East Pier, Light was located on Lake Ontario. It no longer stands. (Author collection.)
On the back cover: The Execution Rocks Light is located near the western end of Long Island Sound. It is still an active lighthouse. (Author collection.)

POSTCARD HISTORY SERIES

New York State Lighthouses

Robert G. Müller

ARCADIA
PUBLISHING

Published by Arcadia Publishing
Charleston SC, Chicago IL, Portsmouth NH, San Francisco CA

Printed in the United States of America

Library of Congress Catalog Card Number: 2005939055

For all general information contact Arcadia Publishing at:
Telephone 843-853-2070
Fax 843-853-0044
E-mail sales@arcadiapublishing.com
For customer service and orders:
Toll-Free 1-888-313-2665

Visit us on the Internet at http://www.arcadiapublishing.com

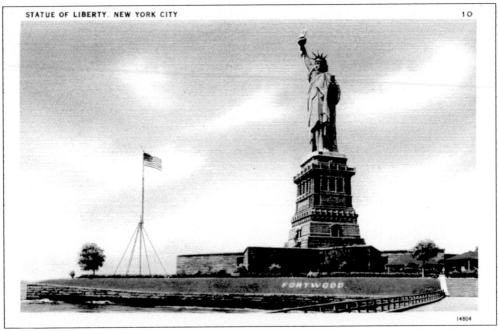

STATUE OF LIBERTY, NEW YORK CITY 10

The Statue of Liberty may be the world's most famous lighthouse, even though it only served as an official aid to navigation for 16 years—from its establishment in 1886 to 1902. It was built on Bedloe's Island (now Liberty Island) within the 24-foot-high walls of Fort Wood. The fort, the walls of which form an 11-point star, was built in the early 19th century to defend New York Harbor.

CONTENTS

ACKNOWLEDGMENTS

There are always more people to thank than there are pages in which to do so, but I would like to point out a few people whose help was pivotal in the making of this book, be it through assistance and/or inspiration:

Jerry Leeds, for sparking my interest in historic lighthouse postcards; the St. James General Store; Guy Edwards and the entire staff and board of the East Islip Public Library; the Fire Island Lighthouse Preservation Society; the many postcard merchants on eBay who happily take my money; my bandmates in Sampawams Creek and the Juke House Blues Band; Don Henninger, for hearing about this book project and the history therein way too many times for a mere mortal to endure; the many people who continue to encourage me to research and write about lighthouses; U.S. Lighthouse Society founder Wayne Wheeler and the society's staff and chapters; the Bahnsen family, especially my research and writing assistant Jackie; Chuck and Jessie Kuhn; Stephen and Fred Fragano; Tony Tuliano; Bill Edwards; Joe Kiebish; my family and friends; my wife and personal editor, Diane Mancini; and Pam O'Neil, my editor at Arcadia Publishing.

INTRODUCTION

Many people are surprised at the number of lighthouses in New York. Tell them that only Michigan has more lighthouses, and the response will often be, "Are you sure?" Reflection on the state's geography and history (the latter is generally a result of the former) will soon bring the matter into view.

New York borders on two Great Lakes, the Saint Lawrence River, Lake Champlain, Long Island Sound, New York Harbor, and the Atlantic Ocean. The state includes the Hudson River, East River, Fisher's Island Sound, Gardiner's Bay, and the Erie Canal, as well as a host of other lakes, harbors, and bays. The sheer number of these waterways and miles of coast alone would make for a great number of lighthouses, but add to that the fact that New York has long been one of the most important ports in the world and one can begin to understand the basis for the state's rich lighthouse heritage.

Surrounding that important port are some dangerous waterways and navigational dangers. The tricky waters of Hell Gate, Plum Gut, and the Race, the sandbars off the south shore of Long Island, the shoals and reefs of Long Island Sound, and many other factors have long demanded that there be many aids to help mariners in the area.

New York State contains one of the oldest lighthouses in America, as well as one of its tallest. It also has a lighthouse built relatively late in U.S. lighthouse history, as well as some very small towers. There are stories of shipwrecks, rescues, whaling, rumrunning, and other exciting activities at or near many of New York's lighthouses. There are war stories that traverse American history. There are lighthouses that were lost to nature and man, and others rescued by volunteer groups and kept open for our education and enjoyment.

The architectural styles, building materials, sizes, and shapes of New York's lighthouses may be unsurpassed in the entire nation. The long period (technologically speaking) during which lighthouses were built in New York—from 1796 to 1912—as well as the diversity of waterways they were designed to serve and environmental conditions they would have to endure, ensured a great sampling of American lighthouse design, construction, and technology. Lighthouses of wood, various types of stone, bricks, cast iron, and concrete were built on land, on piers, and offshore in many architectural styles, including Gothic Revival and Second Empire. These ranged in height from about 20 feet to nearly 170 feet. As you read through this book, realize that the variety of lighthouses you are seeing were all built in one state in a period of about 125 years.

Throughout this book, reference is often made to Fresnel lenses and the various orders thereof. The Fresnel lens is a type of lens invented by French physicist Augustin Jean Fresnel in the early 1820s. Fresnel's lens design, which replaced multiple oil lamps and reflectors with a single

lamp and lens, allowed for much greater brilliance and efficiency in lighthouse illumination. European lighthouse systems adopted Fresnel's system almost immediately, while administrative difficulties in the United States delayed its widespread use until the 1850s. Fresnel lenses were produced in several common sizes, or orders, ranging from the Sixth Order, which would fit on a tabletop, to the huge First Order, in which several people could fit inside. The larger lenses, with powerful lamps inside, were used in tall coastal towers, while the smaller lenses and lamps guided mariners in smaller waterways. The most common country of origin of these lenses was France. Fresnel lenses began to be phased out with the introduction of electric lamps, which could produce a powerful light without the need of a lens.

In the following pages, you will get an introduction to the lighthouses of New York State, as seen through the eyes of early-20th-century postcard illustrators, photographers, and publishers. Unfortunately, not all of New York's lights were the subjects of postcards—if they had been, this would be a multivolume work—but enough of them were produced to give readers an idea of the vastness and variety of New York's lighthouse heritage.

Some lights were more popular for use as postcard subjects than others. Where there were too many of one lighthouse to use them all, I have tried to choose those that provide a fair representation of the whole, as well as using the more visually interesting ones. If your favorite New York lighthouse is not included, it is because it was not the subject of any postcards or, if it was, those particular postcards are very rare and a usable original was not available for this book.

Some of the lighthouses in the following pages no longer stand. Others have gone through tough times but have been restored. And some are currently in danger of "demolition by neglect." The great rise in American historic lighthouse preservation, sparked largely by the creation of the U.S. Lighthouse Society in 1984, gives hope to those concerned about the future of our lighthouse history. The continuation of this trend requires a great deal of hard work, money, and awareness. Groups all around the nation need support.

The trail does not end in this book. I encourage you to learn more about the history of these lighthouses and their surroundings. A map of New York will help you to better imagine the settings of these stations. If you have internet access, any one of several searchable maps will give you a closer view, sometimes with the option of satellite views. To truly appreciate and enjoy the history contained herein, however, you must visit these sites, listen to the stories, and feel the history for yourself.

One

LAKE ERIE

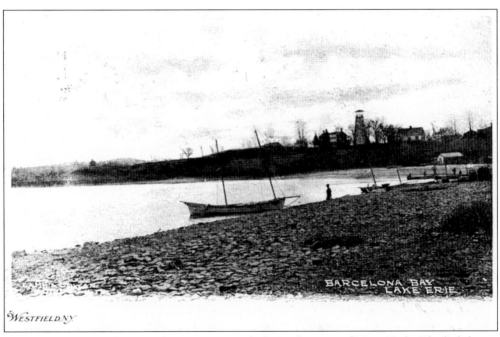

The Barcelona Lighthouse is the westernmost light in the state of New York. The lighthouse was built on the shore of Lake Erie in 1828. Five thousand dollars was appropriated for it, but only $3,500 was spent. The 40-foot tower was made of stone and was finished in 1829.

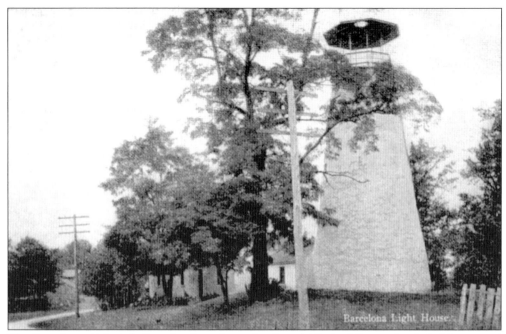

The Barcelona Light is believed to have been the first public building to be fueled by natural gas, as well as the only lighthouse in the world ever fueled by its own gas deposit. Local settlers described the local gas deposit as a "burning spring." The lighthouse was connected to this natural gas supply by two miles of wooden pipes. The gas from the spring was also used to light local buildings.

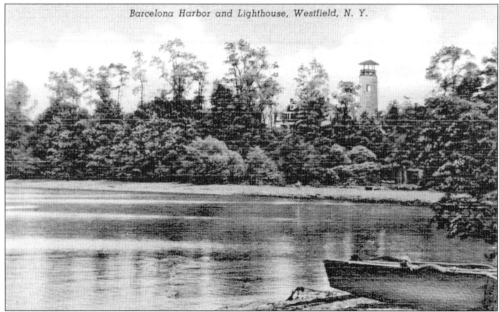

Barcelona Harbor and Lighthouse, Westfield, N. Y.

The original optic in the Barcelona Light had 11 lamps with 14-inch reflectors. In 1851, the tower showed a fixed white light visible for 16 miles in clear weather. In 1857, a Fourth Order Fresnel lens was installed in the lighthouse, with the light still provided by gas lamps. These lamps and the Fresnel lens showed a fixed white light visible for 14 miles.

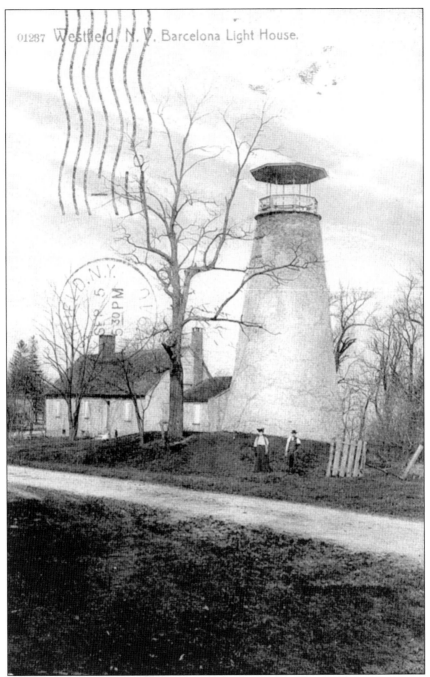

01287 Westfield, N. Y. Barcelona Light House.

The Barcelona Light was originally called the Portland Harbor Light. Despite the name, there was not a usable harbor nearby. The Light–House Board began to note this fact in its Annual Reports to Congress in the 1850s, referring to the light as being "useless," along with recommendations that it be discontinued. The first keeper at Portland Harbor, Joshua Lane, was appointed on May 27, 1829. He was reported to be a "deaf, superannuated clergyman, having numerous female dependents." His pay was $350 per year. In 1855, the keeper of the Barcelona Light was Thomas Taylor. He was also paid $350 per year for his services.

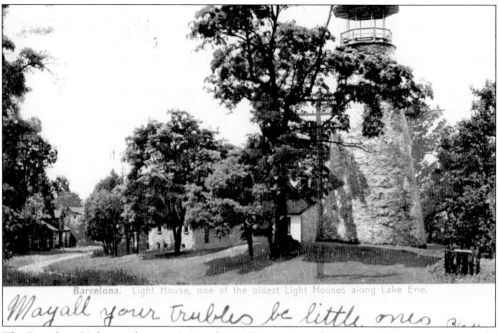

Barcelona. Light House, one of the oldest Light Houses along Lake Erie.

Mayall your trubles be little ones

The Barcelona Light was decommissioned in 1859, serving only 30 years. The property was sold in 1872, and stayed in the same family until 1998, when new owners purchased the property and lighthouse. The stone tower and keeper's dwelling both still stand. The present optic at the top of the lighthouse is a gas streetlamp installed in 1962.

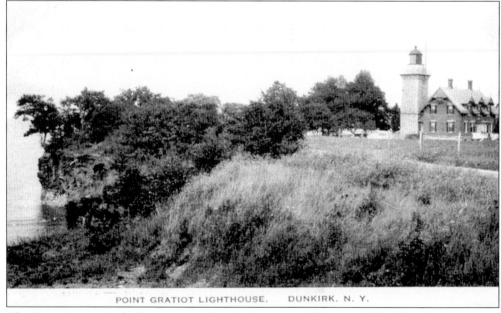

POINT GRATIOT LIGHTHOUSE. DUNKIRK, N. Y.

The Point Gratiot Light Station, near Dunkirk, was established in 1827. The first tower was made of bricks from local clay. The light was discontinued around 1838, but reestablished shortly thereafter. By June 1850, the tower had cracked. The crack was severe enough to allow rainwater to dampen the steps inside the tower. Also at this time, the wood around the tower windows was badly rotten. The cost to repair these problems was estimated to be $45.

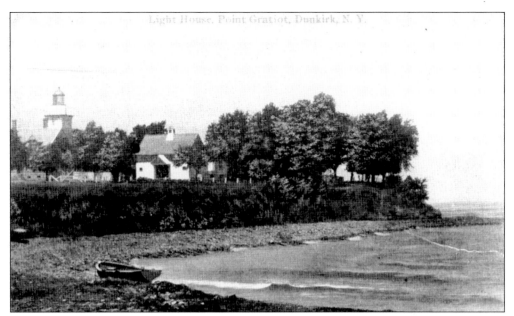

In the early 1850s, the Dunkirk Light's nine oil lamps, using 14-inch reflectors, were burning 335 gallons of whale oil per year. This level of consumption, 37.2 gallons per lamp per year, was higher than the expected consumption of 27 gallons per lamp per year. In 1857, the lighthouse was updated and a Third Order Fresnel lens was installed. In 1858, the 30-foot tower showed a fixed white light varied by flashes. The light was visible for 16 miles.

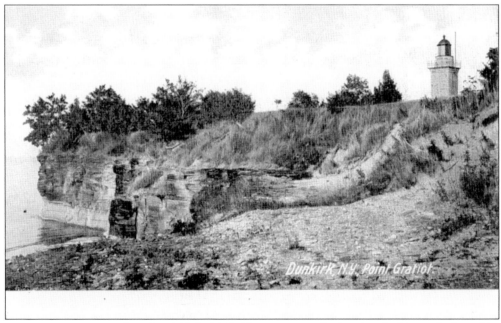

Major repairs were made at Dunkirk in 1869. The tower was "pointed and whitewashed outside, and thoroughly repaired inside." The keeper's house was "refloored, reshingled, replastered, and painted," and windows were added to increase ventilation. Other repairs included a covered walkway between the house and tower, and a new fence and privy.

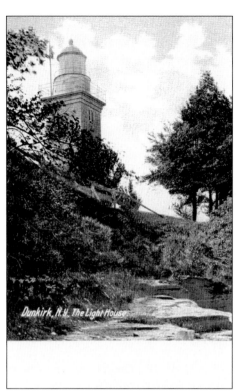

The Dunkirk Light was rebuilt in 1876 because of the eroding bluff and deterioration of the tower. The new lighthouse, as seen in these postcards, consisted of a 61-foot stone tower and adjacent keeper's quarters. The keeper's house has a gray limestone foundation and is made of brick. The tower is made of limestone; the two upper stories are painted white.

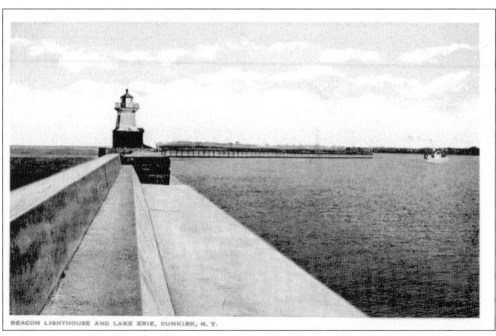

BEACON LIGHTHOUSE AND LAKE ERIE, DUNKIRK, N. Y.

In 1837, the Dunkirk Beacon Light was established on a pier on the west side of the entrance to Dunkirk Harbor. This light briefly guarded Dunkirk Harbor by itself, but was not visible from the northwest because of a bluff. The light was fitted with a Sixth Order Fresnel lens in 1854. The white, 25-foot-tall tower cast its fixed white light 40 feet above the water.

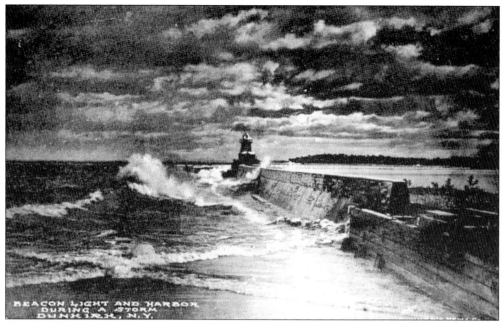

The Dunkirk Beacon Light was tended by the keeper of the Dunkirk, or Point Gratiot, Light. It was considered "indispensably necessary" for ships seeking the harbor "in foul weather." In 1855, the light's keeper, Jonathan G. Cassily, was making $550 per year tending these two lights, more than any other keeper on Lake Erie or Lake Ontario.

A lighthouse, built in 1838, once stood at Silver Creek, northeast of Dunkirk. In 1851, the tower's four oil lamps with 16-inch reflectors showed a fixed white light 27 feet above the water and burned 123 gallons of oil per year. In 1854, the Light-House Board reported that the lighthouse was useless and should be discontinued. By 1858, the Silver Creek Light no longer appeared in official light lists.

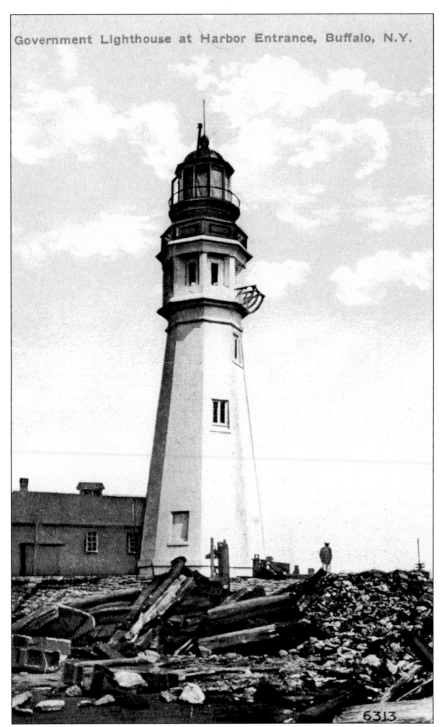

Government Lighthouse at Harbor Entrance, Buffalo, N.Y.

6313

The first lighthouse at Buffalo was constructed on the shore of the harbor in 1818, at the same time as the Presque Isle Light in Pennsylvania. These were the first two lighthouses on the Great Lakes. Buffalo received a new lighthouse in 1833 in response to the increased traffic following the opening of the Erie Canal. This tower still stands.

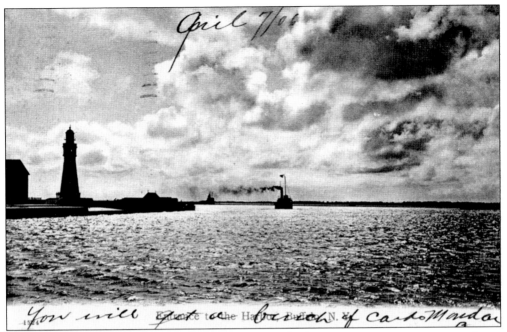

Buffalo's 1833 light was 61 feet tall when first built. The limestone tower was constructed on a pier that was built 13 years earlier. In 1838, the Buffalo Light contained 15 lamps with reflectors. In 1857–1858, the tower was raised and modified to accept a Third Order Fresnel lens. This put the light at 76 feet above water level. A fog bell was also installed at the station at this time.

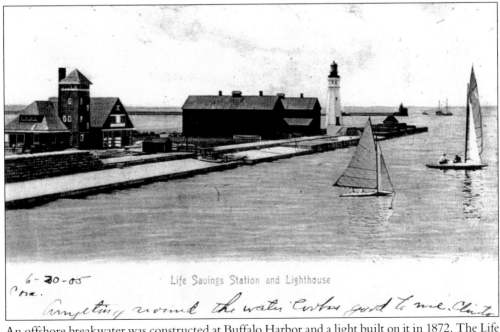

Life Savings Station and Lighthouse

An offshore breakwater was constructed at Buffalo Harbor and a light built on it in 1872. The Life Saving Station was established on the site near the 1833 lighthouse in 1879. The Life Saving Station (far left) and 1872 lighthouse (offshore, to the right of the old tower) can be seen in this postcard.

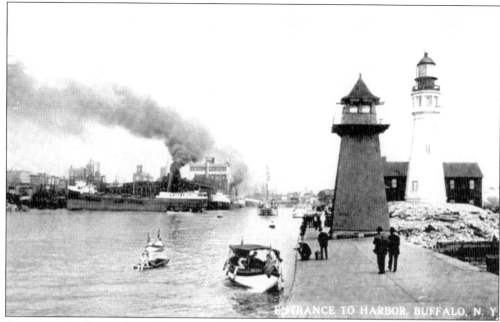

ENTRANCE TO HARBOR, BUFFALO, N. Y.

A tower was built near the Buffalo Lighthouse for use as a lookout by the Life Saving Station. This tower's pagoda-like appearance earned it the nickname of "Chinaman's Light." This nickname, in time, was transferred to the 1833 lighthouse, and it is still sometimes referred to as such.

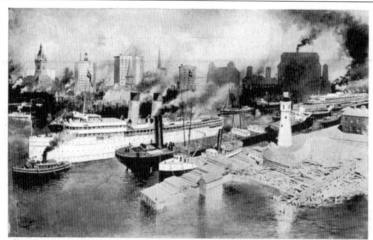

The Mouth of Buffalo Harbor. Buffalo Morning Express—Niagara Frontier Series.

The Buffalo Breakwater Light, which had suffered from the elements and collisions with ships, was rebuilt between 1912 and 1914. When completed, it was given the 1833 lighthouse's Fresnel lens and the old lighthouse went dark. The tower remained unused for many years. It was restored in 1962, and again in 1985, when the Buffalo Lighthouse Association was formed. The group still maintains the tower.

Two

LAKE ONTARIO

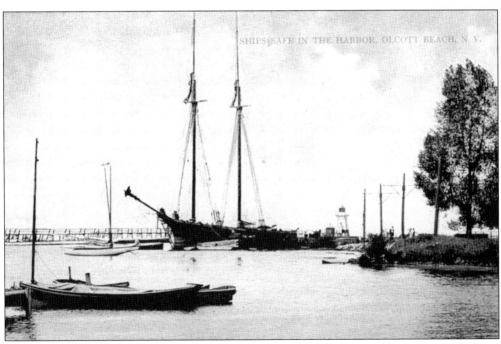

The Olcott Light, which served from 1873 to about 1932, can be seen in the background of this postcard. It was located in the southwestern part of Lake Ontario, between the lighthouses at Fort Niagara and Thirty Mile Point. The light was relocated to a nearby yacht club in 1930. It remained there until 1963, when it was demolished. A replica of the small wooden tower was built in 2003.

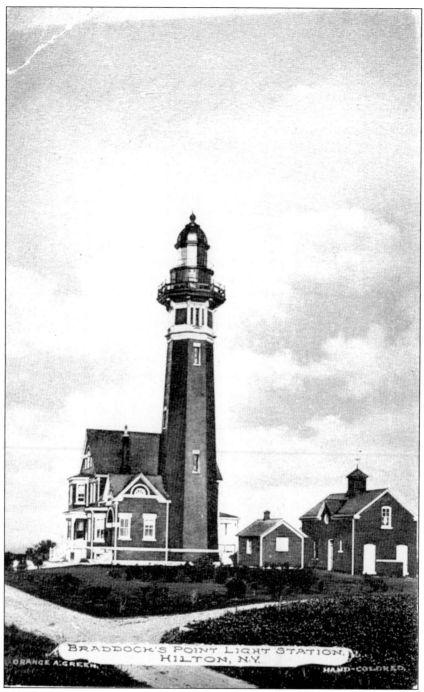

BRADDOCK'S POINT LIGHT STATION.
HILTON, N.Y.
ORANGE A. GREEN.
HAND-COLORED.

The Braddock Point Light, built in 1896, was constructed partly of materials taken from the demolished Cleveland (Ohio) Lighthouse, including the lantern room and lens. The 110-foot tower showed a light from its Third-and-One-Half Order Fresnel lens until 1954. The Coast Guard then dismantled most of the structurally unsound tower, and the site has been privately owned since 1957. The shortened tower was given a faux lantern room by its owners and was relit as a private aid to navigation in 1999.

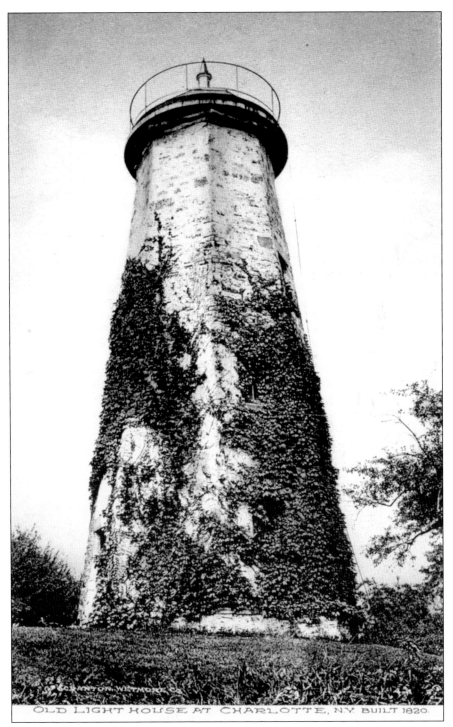

OLD LIGHT HOUSE AT CHARLOTTE, N.Y. BUILT 1820.

The Charlotte-Genesee Light was built in 1822 of red sandstone. The 40-foot stone tower was built largely to help ships avoid a sandbar at the mouth of the Genesee River, at the Port of Genesee. The lighthouse was decommissioned in 1881. As seen in this postcard, the lantern room was removed after retirement, and vines grew on the abandoned tower.

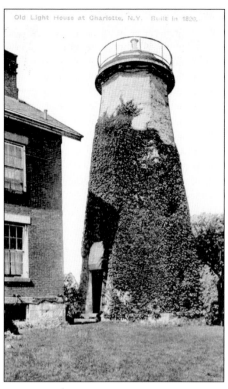

Old Light House at Charlotte, N.Y. Built in 1820.

The 1863 keeper's quarters at the Charlotte-Genesee Light, the corner of which is seen in this postcard, now serve as a museum. A covered walkway that once attached the two structures no longer exists. A replica lantern, built by local students, was installed on the tower in 1984. The Charlotte-Genesee Lighthouse Historical Society manages the site.

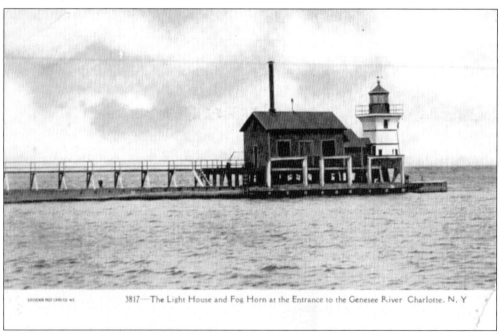

3817—The Light House and Fog Horn at the Entrance to the Genesee River Charlotte, N. Y

The Genesee North Pier Light was established in 1881. The lantern and lens came from the old Charlotte-Genesee Light. The station included a fog signal, the building for which can be seen adjacent to the tower in the above postcard. This tower was removed in 1931. A modern cylindrical tower, erected in 1995, which is white with a red stripe, now sits at the end of the pier.

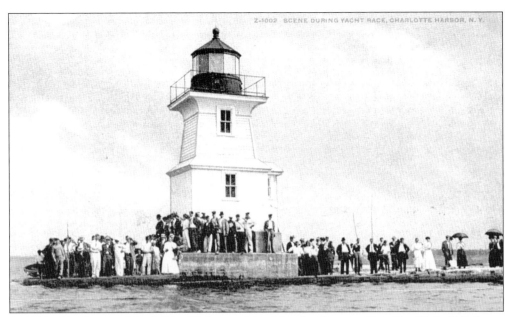

In 1902, the Genesee North Pier Light was joined by the Genesee East Pier Light (a light on the east pier). This light, also known as the Summerville Light, was a square pyramidal tower constructed of wood. The location provided a good vantage point from which to watch the goings-on near the mouth of the Genesee River. In this postcard, people are gathered to watch a yacht race. This tower no longer stands.

Light Houses, Charlotte, N.Y.

Both pier lights at the entrance to Charlotte Harbor are seen in this postcard. The left tower, approximately in the middle of the card, is the North Pier Light, with its fog signal building. The small tower on the right is the East Pier, or Summerville Light. A pier light at this site to replace the Charlotte-Genesee Lighthouse was first proposed for the west (north) pier in 1838.

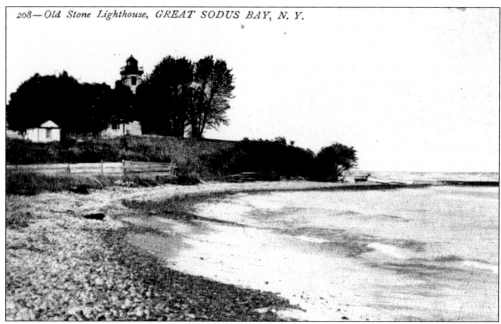

The first light to serve the Sodus Bay area of Lake Ontario was established at Sodus Point, just west of the bay, in 1825. Congress had appropriated $4,500 for the building of the 40-foot stone tower and separate keeper's dwelling a year earlier. The lantern contained 10 lamps and reflectors. When completed, Ishmael Hill was assigned as the station's first keeper.

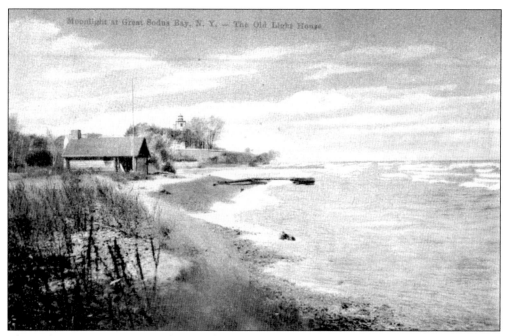

The Sodus Point tower received a Fourth Order lens in 1858. The light, 64 feet above the lake, showed a white flash every two minutes. Even with the new lens, the tower remained leaky and damp, and by 1869 it was considered "not worth general repair." The Light-House Board requested $14,000 for a new tower and attached dwelling, as seen in these postcards.

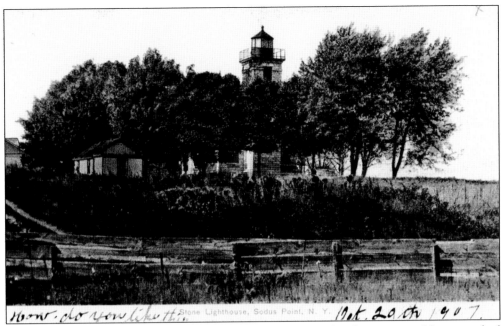

How do you like this Stone Lighthouse, Sodus Point, N. Y. *Oct. 20th 1907.*

The Sodus Point Light was rebuilt in 1871 as a dwelling made of cut stone with an attached square tower. It served for only 30 years before being replaced by a pier light. The Sodus Point Light was leased to the Sodus Bay Historical Society in 1984 and is now open to the public for tours. Concerts are held on the grounds during the summer.

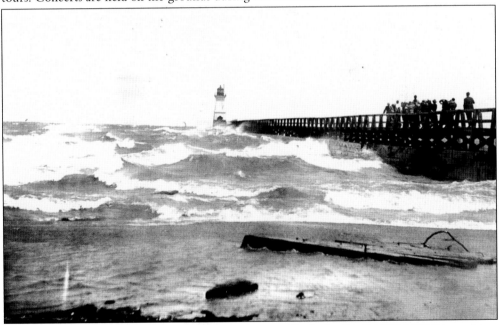

Two stone piers were constructed at the entrance to Big Sodus Bay in 1834. Two years later, a stone beacon was established on the west pier. With a major light at nearby Sodus Point, the beacon was used as "a mere guide for entering the harbor." It was expected that the bay would become a "port of immense importance in a commercial point of view" due to the harbor's "excellent qualities."

In 1851, the beacon on the west pier used four lamps for illumination. Four years later, the Light-House Board recommended the installation of a Sixth Order Fresnel lens. At this time, Jesse Lyman and an assistant were responsible for maintaining both the tower at Sodus Point (where he lived) and the pier beacon.

The Cornelia and Pier, showing Lighthouse at entrance to Sodus Bay Harbor, Sodus Bay, N. Y.

The Sodus Bay Pier Beacon was "destroyed by [a] gale" in 1857. It was rebuilt the following year. In 1870, the pier light was again rebuilt. In 1901, when it took over the duties of the Sodus Point Light, the tower was made taller, as seen in these postcards, putting the light about 45 feet above the lake.

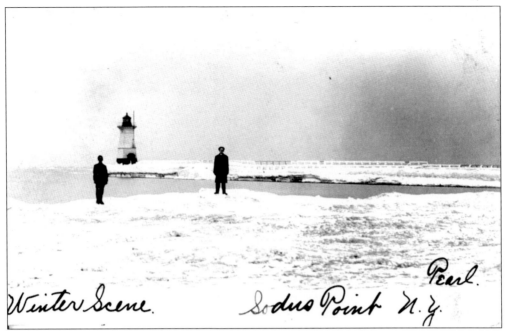

Winter Scene. *Sodus Point N.Y.* *Pearl.*

The wooden tower at the entrance to Sodus Bay was replaced in 1938 with a steel pyramidal tower that held the light 51 feet above the water. This light is still active and is the longest serving tower to be built at Sodus Bay. It can be seen from the Sodus Point Light or the pier on which it is built.

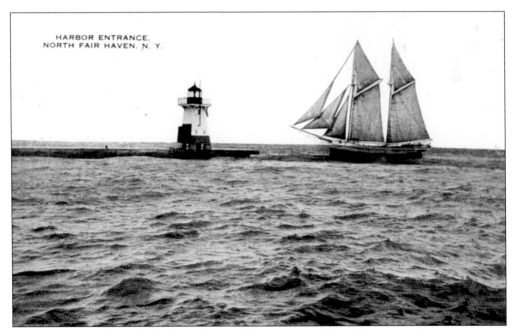

HARBOR ENTRANCE.
NORTH FAIR HAVEN. N. Y.

The Fair Haven Light, at Little Sodus Bay, was first lit on June 10, 1872. The wooden tower, a square pyramid, was built at the end of a pier. The keeper's quarters for the Fair Haven Light were not completed until July 1873, partly because of the difficulty obtaining property for the structure.

27

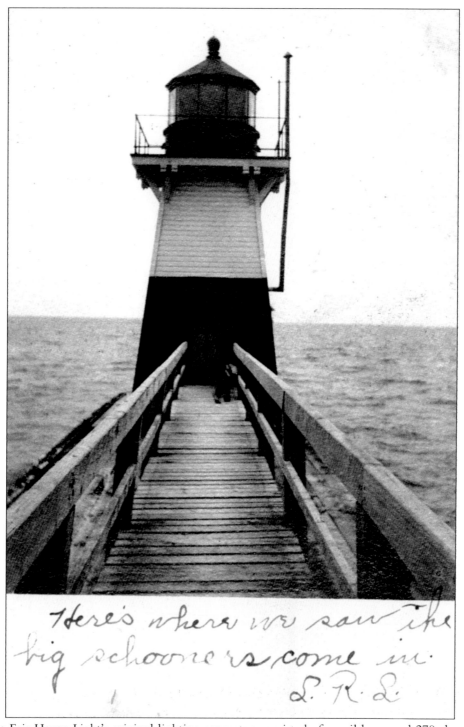

Here's where we saw the big schooners come in. L. R. L.

The Fair Haven Light's original lighting apparatus consisted of an oil lamp and 270-degree Fresnel lens, showing a fixed white light from a height of 34 feet. The tower was removed in 1943 and replaced with an automated skeleton tower. The light's keeper was reassigned. The old keeper's quarters at Fair Haven still stands and is used as a private residence.

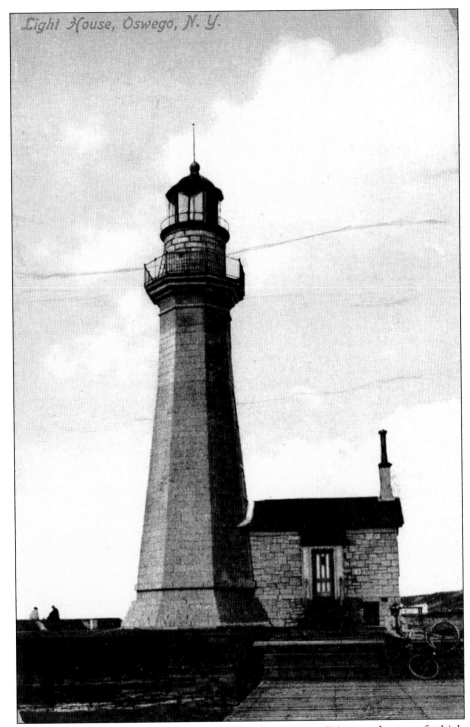

Light House, Oswego, N. Y.

Four lighthouses have served at the entrance to the Oswego River, only one of which still stands. The first, built on the east side of the river at Fort Ontario, was established in 1822. It was replaced by the tower seen above in 1836. In 1838, the Oswego Light used 13 lamps and reflectors to cast its light.

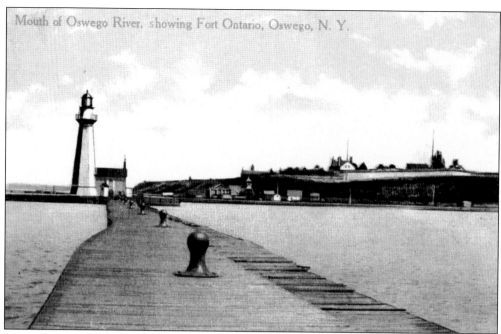

Oswego Harbor was described in an 1838 government report as a "splendid harbor, extending about half a mile in the river, with sufficient depth of water for the largest class of vessels." The harbor's "commercial importance" placed it "beyond competition on this lake." In this postcard, Fort Ontario can be seen on the opposite side of the river.

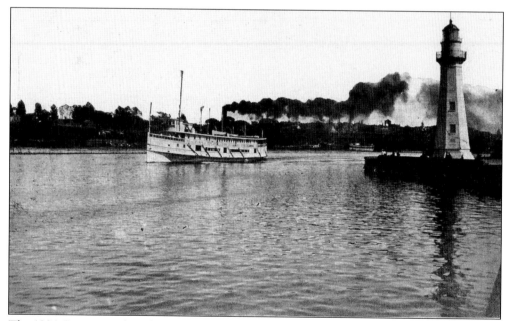

The 1836 Oswego Light, often called the Inner Light to distinguish it from the pier lights, was a grey octagonal stone tower, with an attached oil house. It received a Fourth Order Fresnel lens in 1855, which was replaced by a larger Third Order Fresnel lens in the late 1860s. The change to the larger lens required a new lantern room as well.

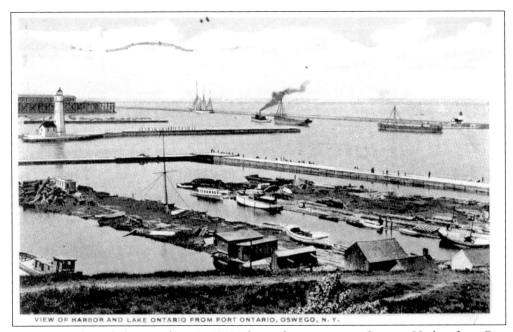

VIEW OF HARBOR AND LAKE ONTARIO FROM FORT ONTARIO, OSWEGO, N. Y.

This postcard, mailed December 10, 1923, shows the entrance to Oswego Harbor from Fort Ontario, the site of the harbor's first lighthouse. The Inner Light can be seen to the left, and the 1880 Beacon Light on the far right. Also seen are the harbor's various piers and many different types of vessels. (Courtesy of Bill Edwards.)

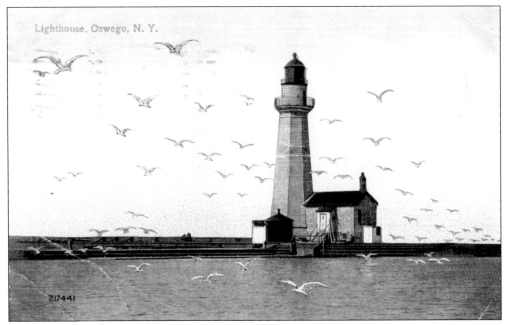

Lighthouse, Oswego, N. Y.

The pier for the Oswego Light was in poor condition in the late 1850s, so much so that the existence of the lighthouse was threatened. A special act of Congress appropriated funds to repair the pier in 1859. The tower was dismantled in 1930, 58 years after the addition of a second light at the harbor.

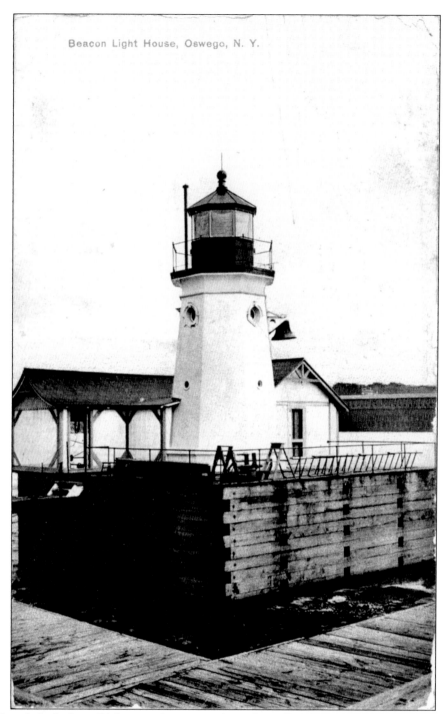

Beacon Light House, Oswego, N. Y.

A light to help the Inner Light serve Oswego Harbor, often called the Oswego Beacon Lighthouse, stood on an offshore pier at the harbor. The first light was built at this site in 1872, with a Sixth Order Fresnel lens showing a fixed white light 23 feet above the water. The wooden framework of the lantern room windows, "with sash-bars nearly 10 inches wide," sometimes obscured the light. The metal tower seen above was built in 1880.

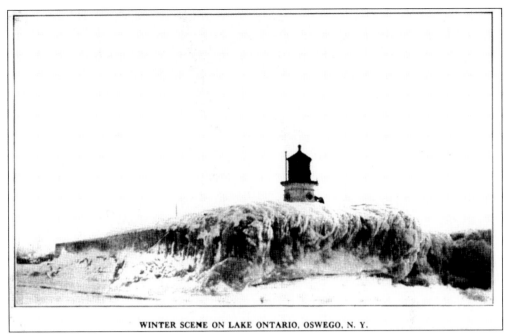

WINTER SCENE ON LAKE ONTARIO, OSWEGO, N. Y.

The Oswego Beacon Light's tower and lantern stand above the ice in this "Winter Scene." The Fresnel lens in the tower at the time, of the Fourth Order, now resides in a nearby marine museum. The station also included a fog signal. In 1920, the signal was deemed inadequate based on petitions received from local mariners.

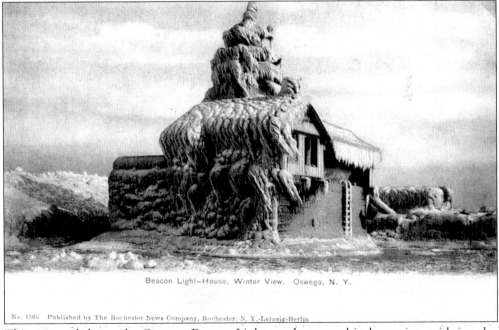

Beacon Light–House, Winter View. Oswego, N. Y.

No. 1566 Published by The Rochester News Company, Rochester, N. Y.-Leipzig-Berlin

This postcard shows the Oswego Beacon Light nearly encased in heavy ice, with ice also surrounding it. The harsh environmental conditions that the Oswego lights, constructed on piers, had to endure required that great attention be paid to inspecting and maintaining the piers. Extensive repairs to the foundations of these lights were required several times.

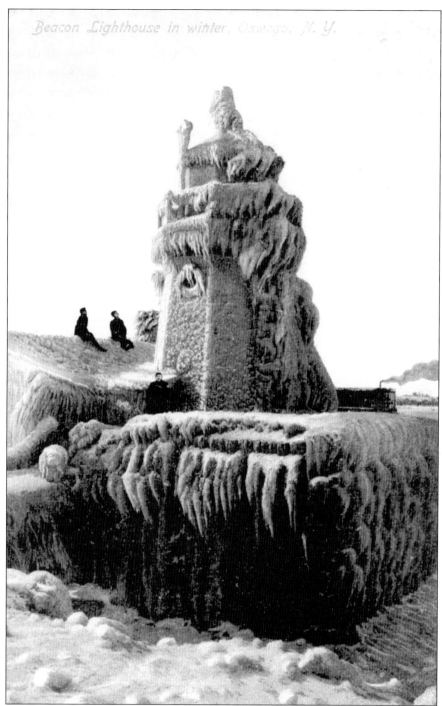

Many postcards were made that reflected the sometimes harsh icing conditions at Oswego. When severe icing on the lake prohibited maritime navigation, the light in the tower was not needed. In this postcard, two people can be seen sitting on the roof of the attached building, while one stands at the base of the tower. In 1934, a new square metal tower replaced the Beacon Light. That light still serves the harbor.

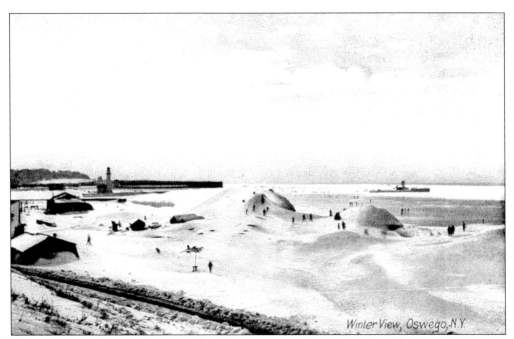

Above is yet another "Winter View" of the entrance to Oswego Harbor. A great deal of ice, as well as both the Oswego Inner and Beacon Lighthouses and many people enjoying the winter fun, can be seen in this image, taken east of the harbor entrance.

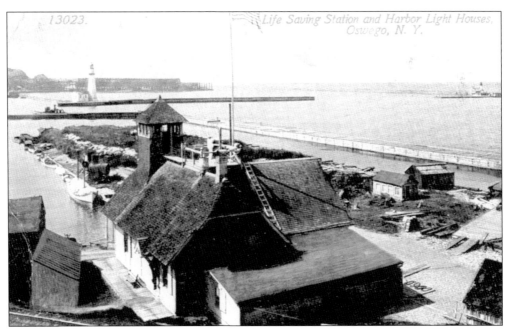

Both Oswego lighthouses, as well as the Oswego Life Saving Station (foreground) are seen in this postcard. The Life Saving Station had been established in 1875, and is still an active Coast Guard station. The Coast Guard eventually absorbed both the Life Saving Service and Lighthouse Service.

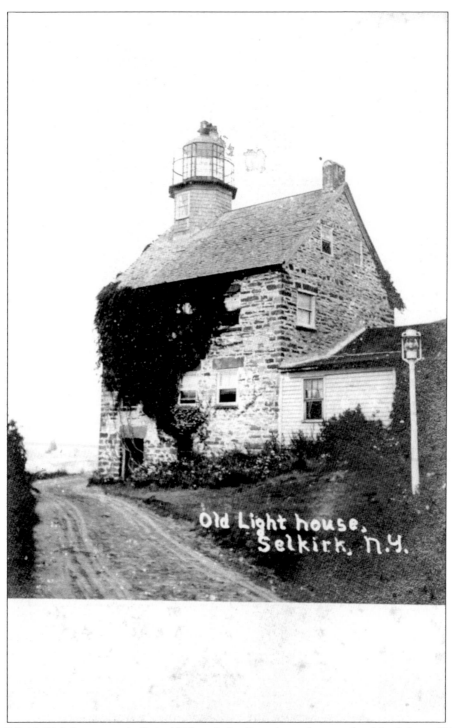

Old Light house, Selkirk, N.Y.

The Selkirk Lighthouse was built in 1838 on Lake Ontario, at the mouth of the Salmon River. The stone dwelling had a tower mounted on the roof. It was built by local contractors, using stone from a nearby quarry, for approximately $3,000. The lantern room was equipped with eight lamps and 14-inch reflectors. Lewis Conant was the light's first keeper and served until 1849.

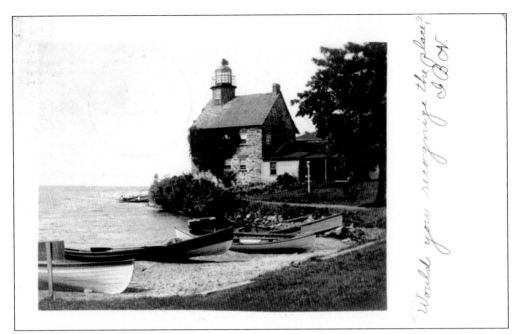

At the time the Selkirk Light was built, its location at the mouth of the Salmon River was thought to be the best site in the area for the protection of ships. Shipping in the harbor at the time included 1.5 million feet of pine lumber, 200 tons of cheese, 5,000 bushels of potatoes, 50 tons of butter, as well as "a considerable quantity of potash."

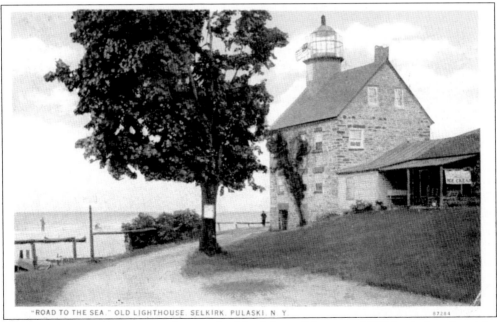

"ROAD TO THE SEA." OLD LIGHTHOUSE. SELKIRK. PULASKI. N. Y. 87284

The construction of two piers at the mouth of the Salmon River, one 1,815 feet in length and the other 1,090 feet, was recommended shortly after the Selkirk Lighthouse was built. These piers, it was believed, would protect at least 30 ships from poor weather. The expectation of a canal from Lake Oneida, which would connect the Salmon River with the Hudson River, justified these suggested improvements. The proposed canal was never built.

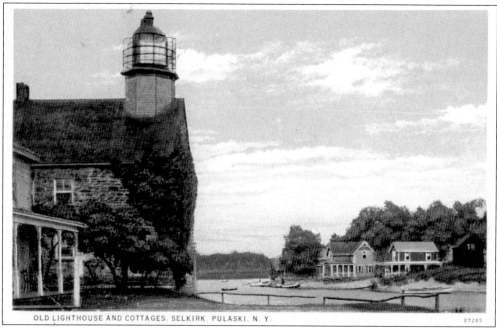

OLD LIGHTHOUSE AND COTTAGES, SELKIRK, PULASKI, N. Y.

87285

In 1850, the Selkirk Lighthouse was reported to be "in good condition" and "very clean," although some of the eight lamps and reflectors were in need of repair. Five years later, the lamps and reflectors were replaced by a Sixth Order Fresnel lens exhibiting a fixed white light 49 feet above the waters of the Salmon River. The Selkirk Light was decommissioned in 1859.

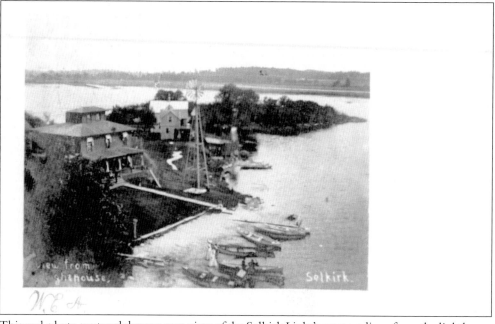

This real-photo postcard shows a rare view of the Selkirk Light's surroundings from the lighthouse itself. Early settlers in the area had been attracted by the plentiful Lake Ontario Atlantic salmon, for which the river was named. This fish was declared extinct in 1898. The area has been restocked, with both Pacific and Atlantic salmon, several times since.

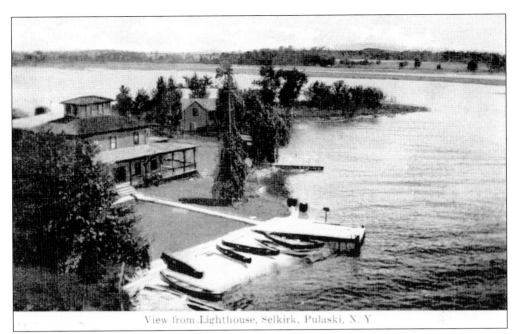

View from Lighthouse, Selkirk, Pulaski, N. Y

A later view from the Selkirk Lighthouse, postmarked 1911, shows vegetation growing on the windmill. The house has had its porch extended around the far side. Today the Selkirk Light is one of very few American lighthouses with an old-style "birdcage" lantern room. The lighthouse is privately owned but is available for overnight stays.

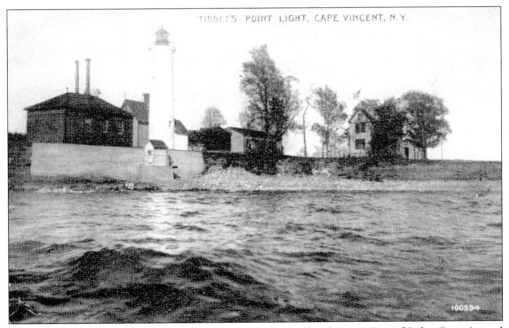

TIBBET'S POINT LIGHT, CAPE VINCENT, N.Y.

Located at Cape Vincent, the Tibbetts Point Light marks the meeting of Lake Ontario and the St. Lawrence River. The first lighthouse here was built in 1827, but was replaced by the current light in 1854. Tibbetts Point is named for Capt. John Tibbetts, who contributed 3 of his 600 acres to the federal government to establish a lighthouse.

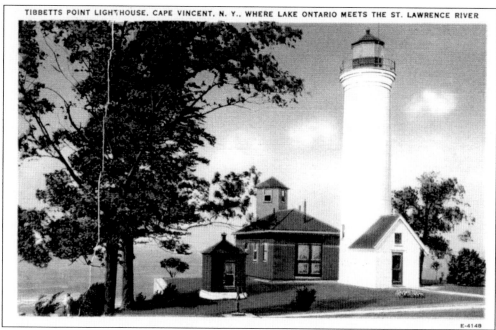

E-4148

Tibbetts Point's circular 1854 tower, made of brick and coated with stucco, stands 69 feet high. Its lantern room houses a Fourth Order Fresnel lens that first cast its light on August 1, 1854. The tower's lens is the only original Fresnel lens still operating on Lake Ontario. There have been several fog signals at Tibbetts Point over the years, but none have been in operation since 1972.

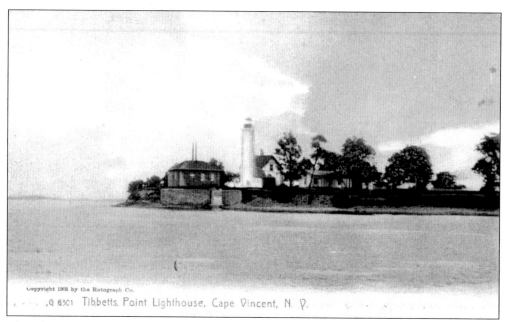

Copyright 1905 by the Rotograph Co.

G 630l Tibbetts Point Lighthouse, Cape Vincent, N. Y.

The Tibbetts Point Light was automated in 1981. Three years later, the keeper's quarters became a youth hostel. Today the Tibbetts Point Lighthouse Society works to maintain the lighthouse and keep it open to the public, which includes a visitor's center and a renovated fog signal building.

Three

ST. LAWRENCE RIVER

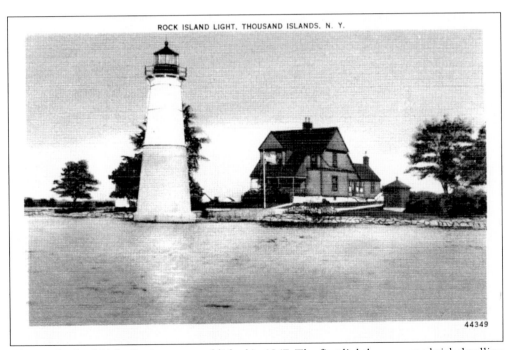

ROCK ISLAND LIGHT, THOUSAND ISLANDS, N. Y.

44349

The Rock Island Light Station was established in 1847. The first lighthouse was a brick dwelling with a short tower and lantern room on the roof. In 1882, the lighthouse and keeper's dwelling were rebuilt. The dwelling was a Victorian-style wooden house, and the tower was a small, conical iron tower.

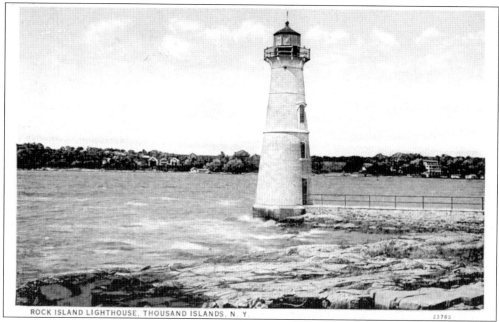

The location of the new tower in the center of the island made it difficult to see, so it was moved to its present location in 1903. It was placed on a conical brick base, making the tower taller. Some views of the lighthouse, such as the one above, show the extended tower, with its original doorway at approximately the half-way point.

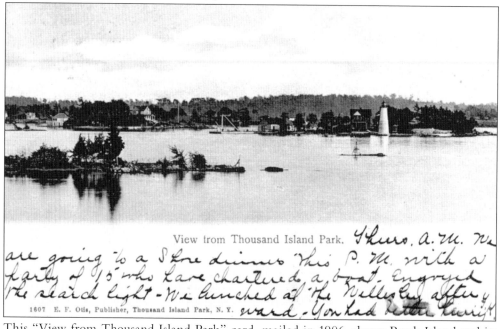

View from Thousand Island Park. *Thurs. a. m. We are going to a Shore dinner this P. M. with a party of 15 who have chartered a boat. Enjoyed the search light - We lunched at the Wellesly afterward - You had better hurry*

This "View from Thousand Island Park" card, mailed in 1906, shows Rock Island and its lighthouse. Several structures still stand on the site, including the 1882 keeper's quarters (seen above), as well as a carpenter's shop (1882), generator house (1900), boathouse (1920), and a stone smokehouse (about 1847). Today the island is a state park and is open to the public. Access is by boat.

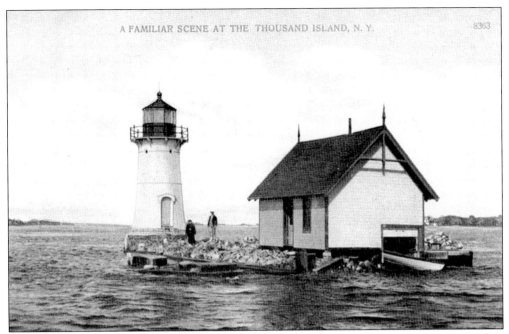

The Sunken Rock Light Station was built upon an artificial island to mark a dangerous submerged rock. The first lighthouse was built in 1847, and was replaced by the current cast-iron tower in 1884. The light is now a private aid to navigation, with a modern flashing green optic in place of the old Fresnel lens. It was converted to solar power in 1988.

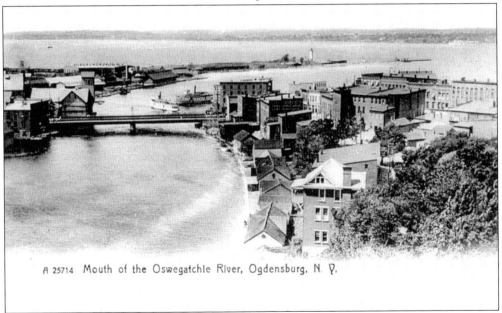

A 25714 Mouth of the Oswegatchie River, Ogdensburg, N. Y.

Ogdensburg was the site of a French fort built in 1749. Near the end of the French and Indian War, the French burned the post as British troops approached. The British later built Fort Oswegatchie on the site and used this fort during the American Revolution. After the war, Americans, under Col. Samuel Ogden, occupied the fort. The town that was later established here was named for Ogden.

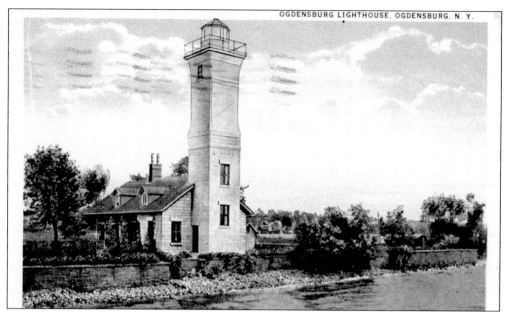

A light was first built at Ogdensburg Harbor in 1834. This lighthouse consisted of a dwelling with a lantern room on the roof. The lantern contained a fixed light produced by 10 lamps with reflectors. This structure was replaced in 1870 with the current lighthouse, a stone building with attached gray and white square tower. Renovations in 1900, including raising the tower, gave the lighthouse its current look.

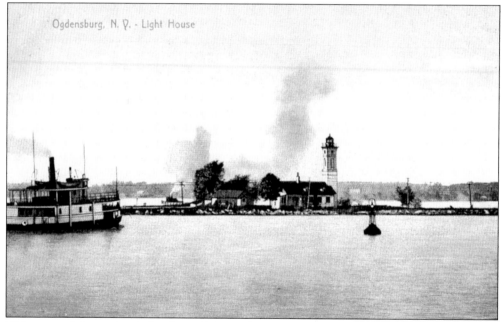

Ogdensburg, N. Y. - Light House

This postcard shows the Ogdensburg Light on the peninsula at the entrance to the Oswegatchie River. This low-lying peninsula was subject to flooding at very high tides. In 1838, the river was running two to three feet higher than usual, flooding the keeper's garden. The Ogdensburg Harbor Light was decommissioned in the 1960s. It is now a private residence and is no longer an aid to navigation.

44

Four

LAKE CHAMPLAIN

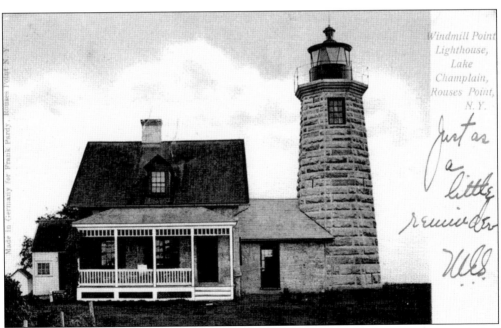

Contrary to the printing on this postcard, the Windmill Point Light is not in Rouses Point, New York. Instead, it resides on the Vermont side of Lake Champlain, America's sixth largest lake. This 1858 lighthouse, visible from New York, is a private residence. The tower was dark for many years but was relit in 2002. It is the northernmost of the Lake Champlain lights.

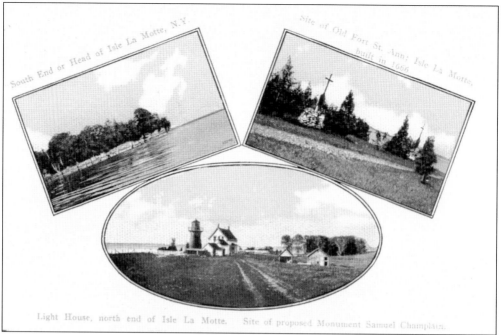

The lighthouse on Lake Champlain's Isle La Motte, south of the Windmill Point Light, is another Vermont light often identified as a New York lighthouse, even in some official Lighthouse Service records. The lighthouse, a 25-foot, cast-iron tower, resides on the north side of the island. It was built in 1880 and is an active light.

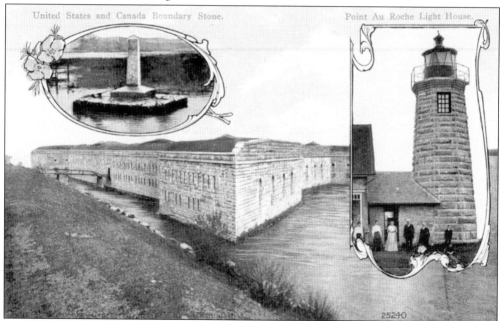

The Point Au Roche (or Point Aux Roches) Light resides on the west bank of Lake Champlain, across from the south side of Isle La Motte. The light was lit in 1858 and served until 1989. The 50-foot, blue-limestone tower originally housed a Sixth Order Fresnel lens. The wood frame keeper's quarters, which was attached to the tower, has been relocated for use as a residence.

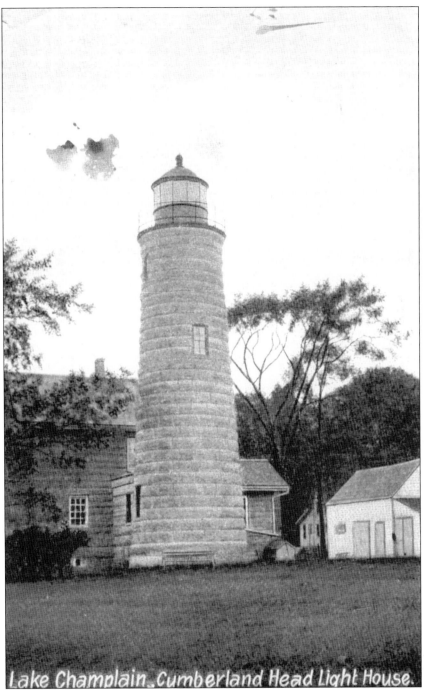
Lake Champlain Cumberland Head Light House.

The Cumberland Head Light Station, east of Plattsburgh, was first established in 1838. The lighthouse and dwelling were both rebuilt of stone in 1868, and a Fourth Order Fresnel lens was installed in the lantern room. The Cumberland Head Light was deactivated in 1934. In 1948, the vandalized lighthouse was bought by a World War II veteran for use as a private residence. The tower remained dark until March 2003, when the light from the skeleton tower that had replaced the lighthouse in 1934 was moved into the old tower.

47

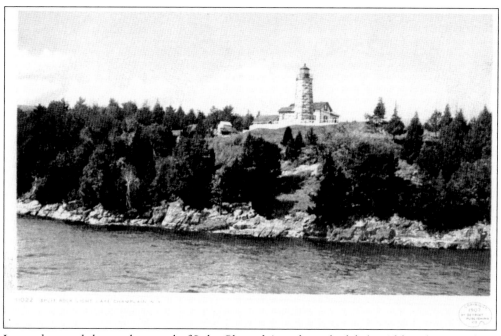

Located toward the southern end of Lake Champlain, where the lake's width reduces to three quarters of a mile, the Split Rock Light Station exhibited a light for the first time in 1838, six years after Congress authorized the station. In 1857, the lighthouse received a Fourth Order Fresnel lens. In 1867, a new limestone tower was put into service at Split Rock.

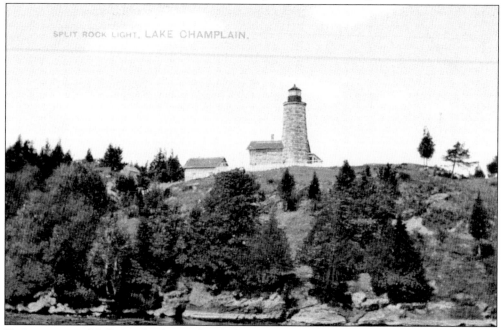

Sitting on top of Split Rock, the 40-foot lighthouse showed a light from about 100 feet above the water. In 1928, the old stone tower's duties were taken over by an automated acetylene light on a steel skeleton tower. In 1931, the old Split Rock tower was sold as surplus, along with its 1899 keeper's dwelling. The Split Rock Light remains privately owned. It was relit in 2003.

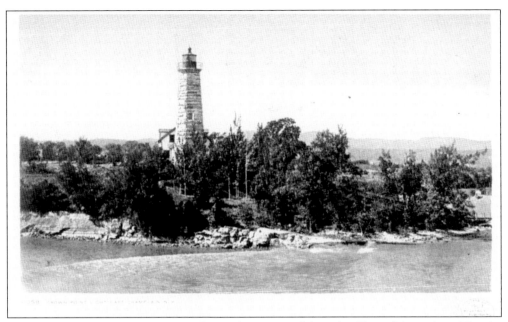

The Crown Point Light Station was the southernmost of the Lake Champlain stations. The site had been a French, and later British, fort. The establishment of a lighthouse at this point had been recommended for more than 20 years, when the Crown Point Light was finally built in 1858. The stone tower cast a fixed white light from a Fifth Order Fresnel lens for many years.

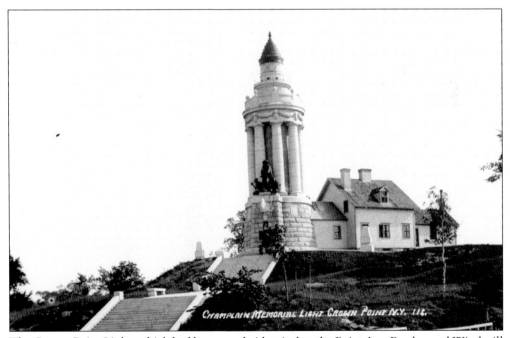

The Crown Point Light, which had been nearly identical to the Point Aux Roches and Windmill Point lights, was renovated to create a memorial to the explorer Samuel de Champlain in 1912. The old keeper's dwelling, which no longer exists, can be seen in this image. The light was discontinued in 1926 and transferred to the State of New York.

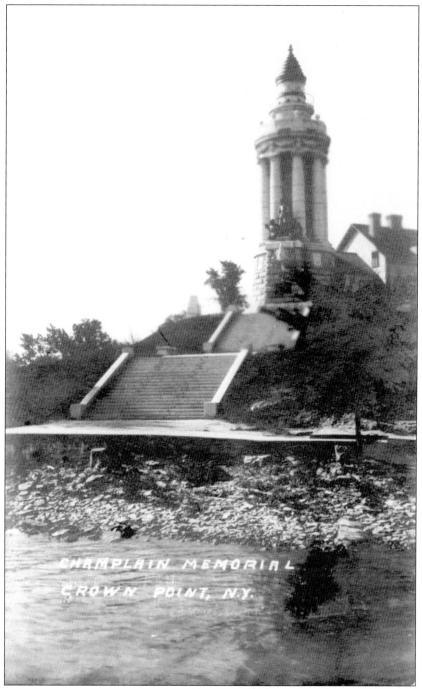

CHAMPLAIN MEMORIAL
CROWN POINT, N.Y.

The central column of the staircase of the old Crown Point Lighthouse and some of the foundation were used in the construction of the memorial. Eight Doric columns were erected around the column containing the stairs. A group of bronze statues, reported by some to have been created by the French sculptor Rodin, stand at the base of the tower. The Crown Point Light, also called the Champlain Memorial, is open to the public. It is located in the Crown Point State Historic Site.

Five

OTHER UPSTATE LAKES

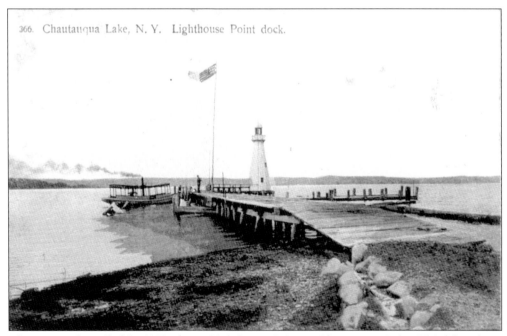

366. Chautauqua Lake, N. Y. Lighthouse Point dock.

This postcard, mailed in 1918, shows Lighthouse Point at Chautauqua Lake. This lake, about 10 miles inland from Lake Erie's Barcelona Lighthouse, once had a railroad line operating along its eastern shore, from Mayville to Jamestown, and was also used by many pleasure craft. The lighthouse was a private aid to navigation. (Courtesy of Bill Edwards.)

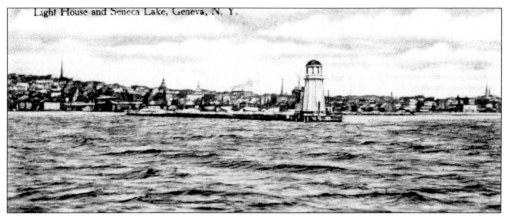

Seneca Lake is the deepest (618 feet) of New York's Finger Lakes. The earliest lighthouse on Seneca Lake was established around 1827 in reaction to increased traffic brought by the Seneca-Cayuga Canal. A new breakwater and lighthouse, seen above, were completed in 1869.

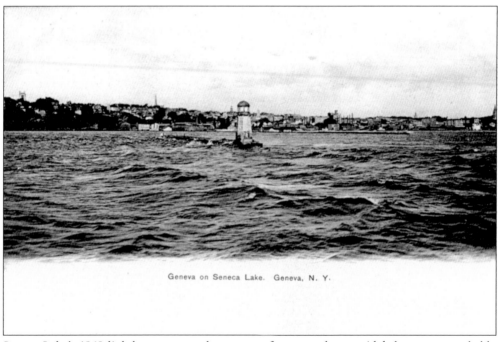

Geneva on Seneca Lake. Geneva, N. Y.

Seneca Lake's 1869 lighthouse, a wooden tower of octagonal pyramidal shape, was probably modeled after the earlier tower. Both the 1827 and 1869 lighthouses on Seneca Lake may have served together for a short time, perhaps until the wooden pier of the old lighthouse burned in 1873. Afterward, the 1869 lighthouse on Lighthouse Pier served alone.

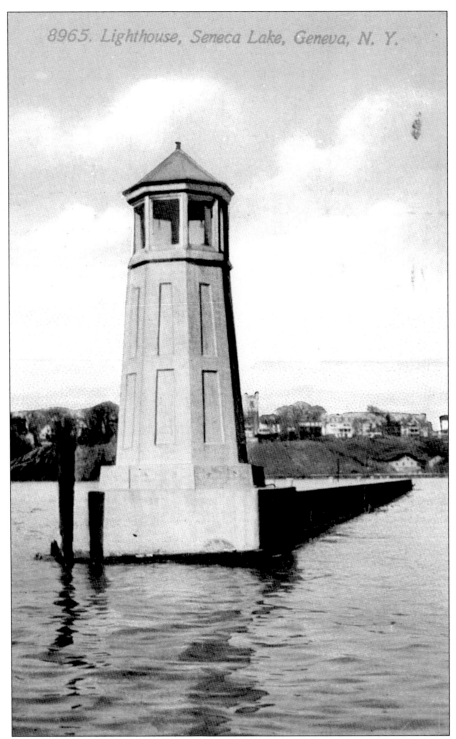

8965. Lighthouse, Seneca Lake, Geneva, N. Y.

In 1907, the wooden lighthouse at Geneva Harbor was replaced with a concrete tower. Like its predecessor, its shape was that of an octagonal pyramid. Its lamp used kerosene for fuel, rather than the oil lamps of previous lights on the lake. In 1925, an electric light was installed.

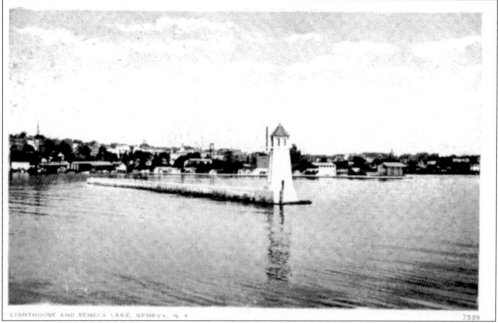

The 1907 concrete tower on Seneca Lake was built by New York's canals and waterways department as part of a comprehensive system of aids to navigation to aid canal traffic. The lighthouse served into the 1940s, when it was replaced with a skeleton tower using battery power, which was subsequently discontinued in the 1980s.

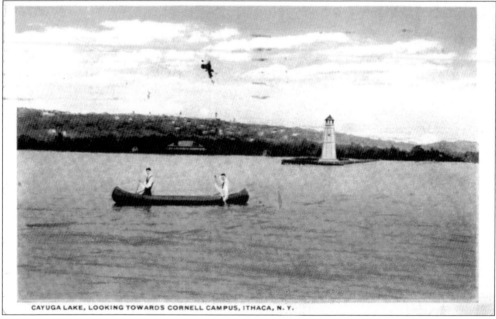

In 1917, a lighthouse was established at Cayuga Lake, near Ithaca. This tower, like others in the Finger Lakes area and the canal system, was built and maintained by the State of New York. It was moved from the west side of Cayuga Creek to the east bank in 1927. The nonresident keepers of these lights were not part of the federal lighthouse system but, rather, were state employees.

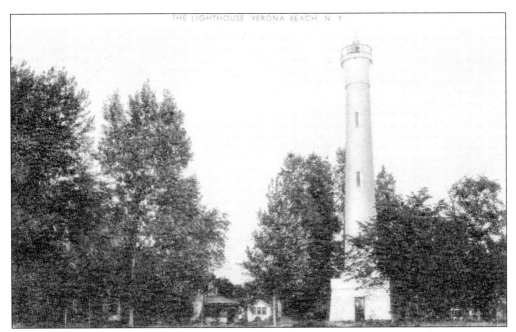

The Verona Beach Light (also known as the Sylvan Beach Light) on Oneida Lake was another of the series of lights built by New York to aid canal navigation. This 85-foot concrete tower does not have a lantern—its light is exposed to the elements. Two similar towers, also built in 1918, were constructed at Frenchman's Island and Brewerton. All three still stand.

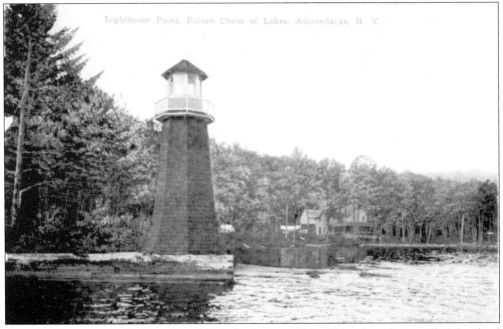

Lighthouse Point, Fulton Chain of Lakes, Adirondacks, N. Y.

A small lighthouse was built on Fourth Lake in the late 1800s. This private light, called the Shoal Point Light, consisted of a red tower and white lantern. It reportedly used a kerosene lamp, and later electricity, for light. Afterward, it was extinguished and neglected. It was restored in 2001. After being unlit for many years, the tower now casts a light from an electric rotating beacon.

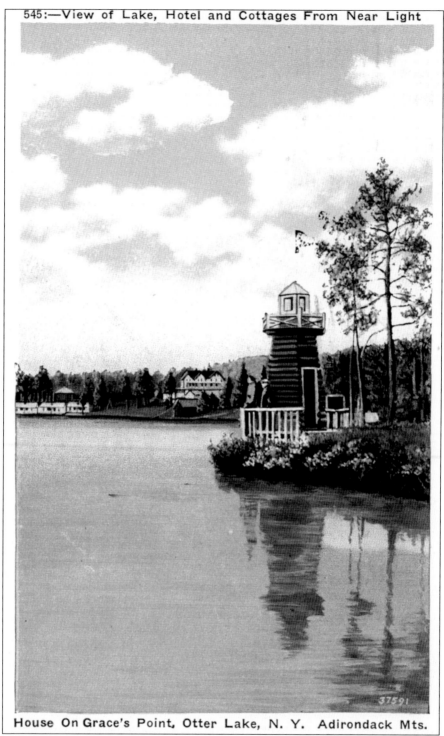

545:—View of Lake, Hotel and Cottages From Near Light

House On Grace's Point, Otter Lake, N. Y. Adirondack Mts.

Very little is known of the "Light House on Grace's Point, Otter Lake" in the Adirondack Mountains. It was almost certainly a private light. Otter Lake is a small lake located northeast of Oneida Lake.

Six

HUDSON RIVER

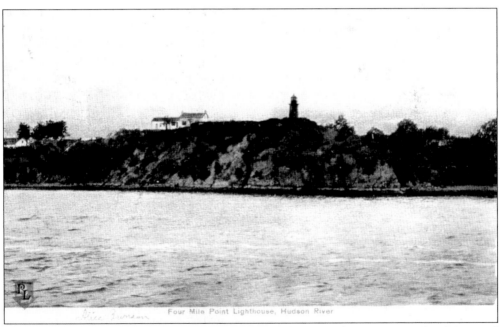

Four Mile Point Lighthouse, Hudson River

The Four Mile Point Light was established in 1831. The original tower was made of stone and included a dwelling for the keeper. Its lighting apparatus consisted of seven lamps with reflectors. In 1850, keeper William Van Vleet was credited with having the "best kept establishment on the river." The tower was rebuilt of cast iron in 1880, and discontinued around 1928. The old keeper's dwelling is now a private residence.

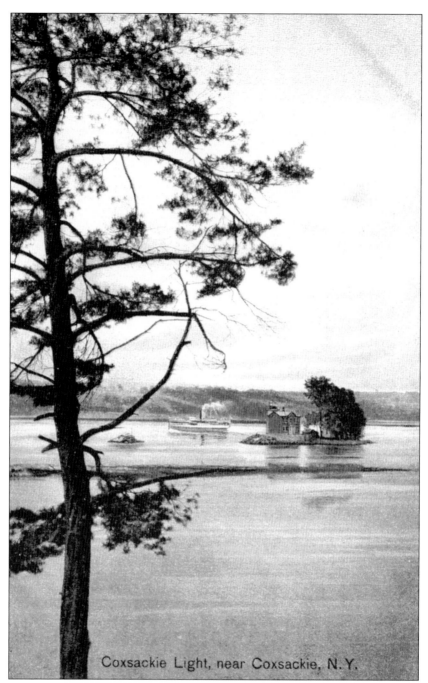

Coxsackie Light, near Coxsackie, N.Y.

The Coxsackie Light Station was established on an island on the west side of the Hudson River in 1829. Like other American lighthouses of its day, it was originally fitted with oil lamps and reflectors. This was changed to a single lamp and a Fresnel lens in 1854. The lighthouse was rebuilt, as seen above, in 1869, with a Sixth Order Fresnel lens in the lantern room. In 1902, a freshet damaged the lighthouse and pier, and carried away at least one outbuilding, as a rush of water from a broken ice jam hit the lighthouse. The lighthouse was closed and torn down in 1939.

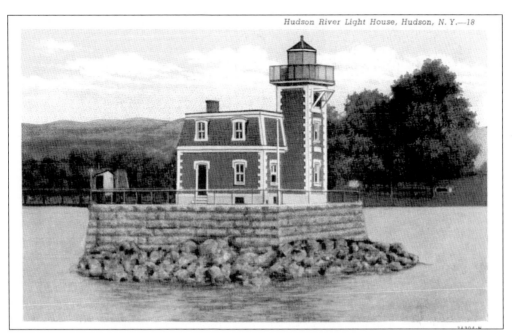

In 1872, Congress approved $35,000 for the building of a lighthouse near Hudson City, on an area called the Middle Ground. These mud flats, which have become an island over the years, posed a danger to ships traveling the Hudson River. To navigate this part of the river, ships needed to stay on the east side, near the city of Hudson. The west side of the flats, near Athens, was too shallow for shipping.

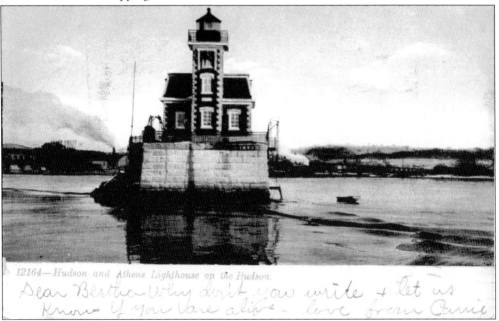

12164—Hudson and Athens Lighthouse on the Hudson.

*Dear Bertha—Why don't you write + let us
know if you are alive — love from Carrie*

The Hudson-Athens Light, originally called the Hudson City Light, showed its light from its Sixth Order Fresnel lens for the first time on November 1, 1874. The lighthouse's pier was designed with a point on one side, like the bow of a boat, to help divert the inevitable ice floes that would threaten the structure. The lighthouse itself was built of brick, in a Second Empire style.

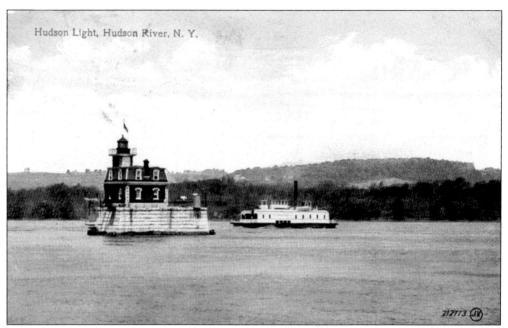

Hudson Light, Hudson River, N. Y.

Henry Best was the Hudson City Light's first keeper. Frank M. Best became keeper of the light in 1893. Among his duties was a 1913 rescue of 11 women from a steamer that had been involved in a collision. In 1919, Frank's daughter, Mrs. Harvey D. Munn, rescued a man and boy from drowning near the lighthouse by launching the station's boat and going to their aid.

VIEW OF THE HUDSON RIVER, SHOWING THE CATSKILL MTS. AT HUDSON, N. Y. 9

In 1926, the light at Hudson City was changed from a fixed beam to a flashing beam. At the same time, a larger Fifth Order Fresnel lens was installed. On December 28, 1946, the lighthouse appeared on the cover of the *Saturday Evening Post*. Keeper Emil Brunner and his family were depicted in the artwork, along with the lighthouse they had been keeping since 1930.

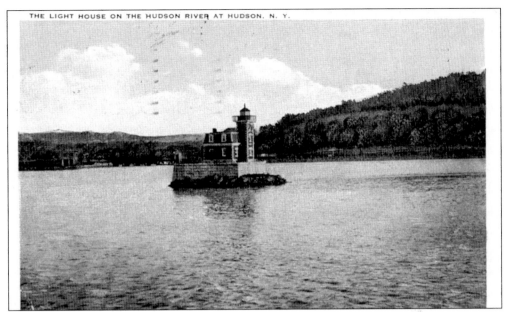

The Hudson-Athens Light was automated on November 10, 1949. It was leased to the Hudson-Athens Lighthouse Preservation Society in 1984. Restoration of the light was completed in 1990. The society, which took ownership of the lighthouse in 2000, continues to work to preserve the lighthouse and its history. The light remains an active aid to navigation on the Hudson River, and is the northernmost remaining light on the river.

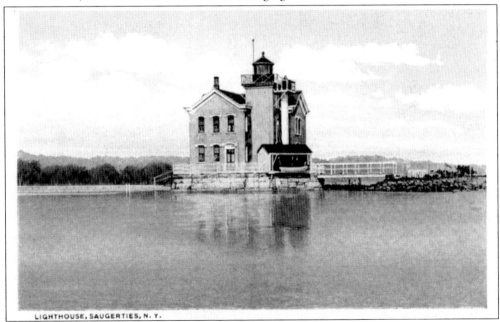

LIGHTHOUSE, SAUGERTIES, N. Y.

The first Saugerties Lighthouse was built in 1838. The present light, seen above, was built in 1869 and given a Sixth Order Fresnel lens. The brick lighthouse was similar in design to several other area lights, including the Coxsackie and Stuyvesant lights. The lighthouse was automated in 1954 and later suffered from neglect. The Saugerties Lighthouse Conservancy, formed in 1985, has restored the lighthouse. It is now an active light as well as a bed and breakfast.

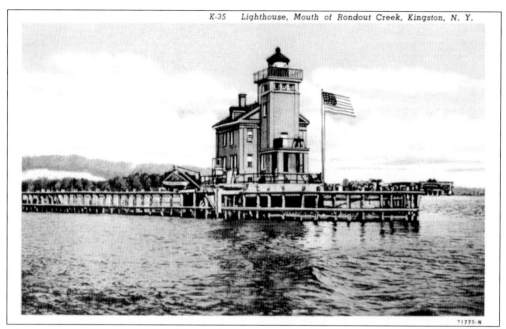

The current Rondout Creek Light, or Kingston Light, was first lit in August 1915. It replaced two previous towers on the creek, built in 1837 and 1868. The buff-colored brick lighthouse, automated in 1954, currently serves as an active aid to navigation and a museum. Since 2002, it has been owned by the City of Kingston.

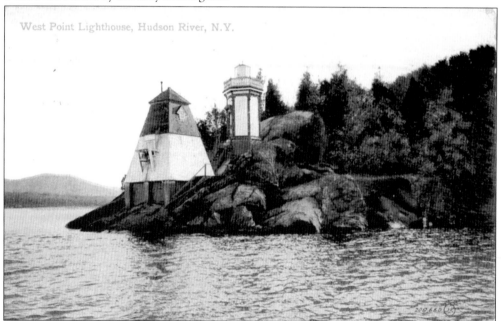

West Point Lighthouse, Hudson River, N.Y.

The first West Point Light was built in 1853 at Gee's Point, to mark a bend in the Hudson River. The river is very deep near this point, and this encouraged ships to get dangerously close to land here. The 32-foot tower, not much more than a post with a light on it, was equipped with a Sixth Order Fresnel lens, showing a fixed white light. John Ellis was appointed as its keeper on December 8, 1853.

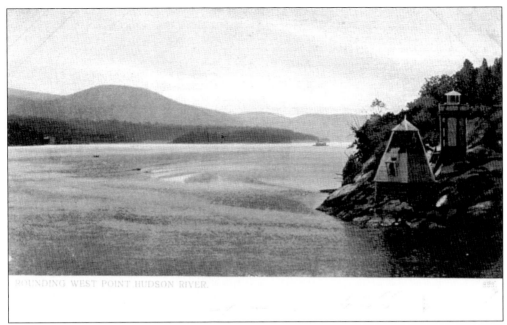

In 1871, an appropriation of $1,500 was made by Congress to rebuild the West Point Light. This was accomplished in 1872, resulting in the structure visible in these postcards. The new wooden hexagonal tower showed a light 40 feet above the river. The old lens was transferred to the new tower, which was built near the former stake light.

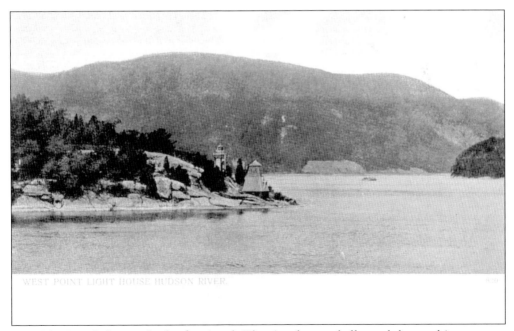

In 1888, West Point received a fog signal. The signal was a bell struck by machinery every 20 seconds in poor visibility. The keeper had to wind the mechanism by hand and ensure that it operated when needed. If the mechanism failed, striking the bell by hand would be necessary.

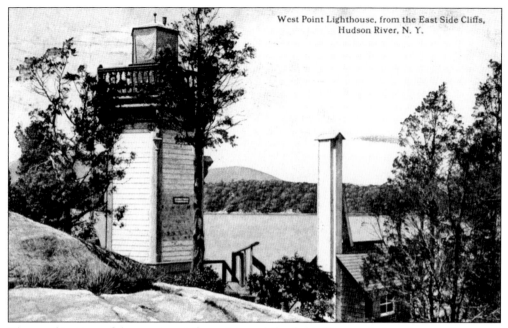

West Point Lighthouse, from the East Side Cliffs, Hudson River, N. Y.

The combination of deep water at the point, and the fog bell tower being close to the water, set the stage for an inevitable collision. In 1921, the fog bell tower at West Point was hit by the schooner *Philip Mehrhof.* The ship had grounded in the river, and the next high tide swept it ashore into the fog bell tower, causing some structural damage.

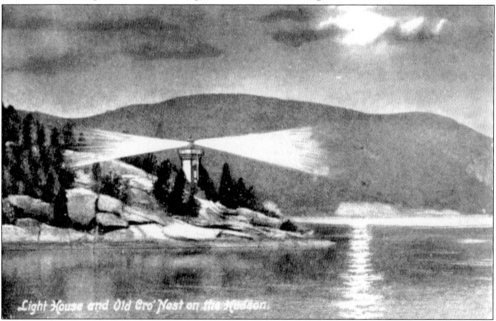

Light House and Old Cro' Nest on the Hudson.

Despite there being no keeper's quarters at West Point, several rescues were made here over the years. Keepers Louis A. Peterson, Stephen J. Nolan, and A. P. Andersen all made rescues, including Andersen's 1922 rescue of two boys whose boat was filling with water and drifting down the river. The West Point Light was discontinued in 1946 and replaced by a skeletal tower exhibiting an automated light.

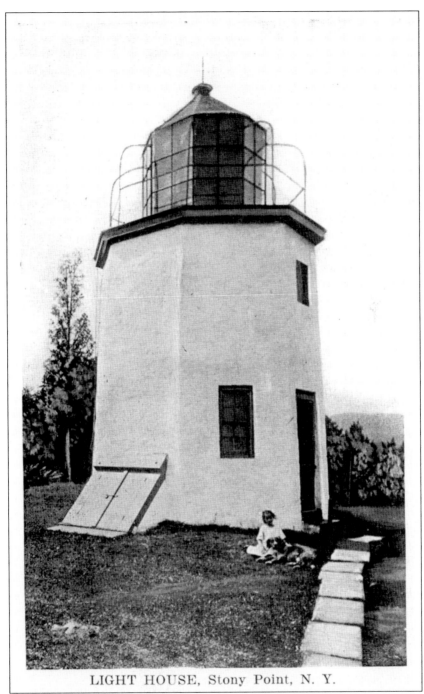

LIGHT HOUSE, Stony Point, N. Y.

The Stony Point Light, approximately seven miles south of West Point, was established in 1826 in response to the increased river traffic brought by the opening of the Erie Canal, which connected the Hudson River to Lake Erie. It is the oldest lighthouse on the Hudson River. The octagonal pyramidal tower, built of stone, and keeper's dwelling were built by Thomas Phillips for less than $3,500. The 20-foot tower was rebuilt in 1850. The work included a new lantern with French plate glass.

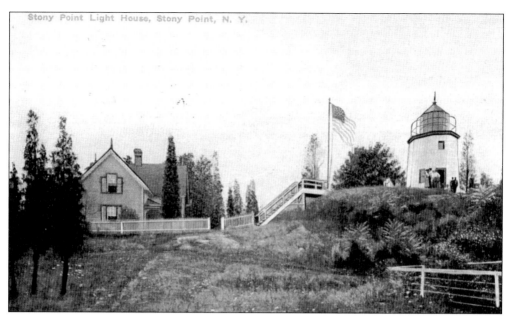

The Stony Point tower's illuminating apparatus saw several changes. It originally housed eight oil lamps, each with a 12-inch reflector. Seven lamps were in use in 1838, but by June 1850, nine lamps were being used. In 1851, the tower housed seven lamps with 16-inch reflectors to cast a fixed white light. In 1855, the Stony Point Light received its first Fresnel lens, of the Fifth Order. In 1902, it was upgraded to a Fourth Order lens.

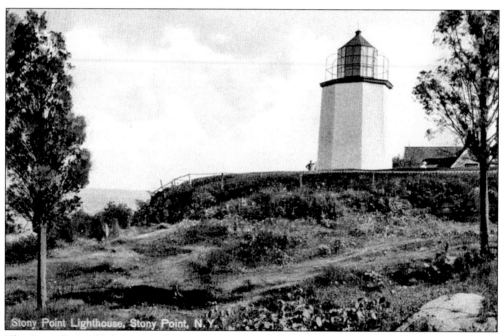

Stony Point Lighthouse, Stony Point, N. Y.

The Stony Point Light's most famous keeper was Nancy Rose, who served at the station from 1857 until her death in 1904. Other keepers included Benjamin Coe, who was there in 1841, and James Miller, in 1850. The keepers lived in a nearby dwelling. The light was decommissioned in 1925, after nearly 100 years of service.

STONY POINT, HUDSON RIVER.

In 1853, the Light-House Board requested $500 from Congress to establish a fog bell, "weighing from 1,000 to 1,500 pounds" at Stony Point, as it was felt "very much required." This bell was installed in 1857. In 1875, the fog bell tower at Stony Point was rebuilt to accommodate the installation of a new striking mechanism for the bell. In 1890, the fog bell was moved closer to the water.

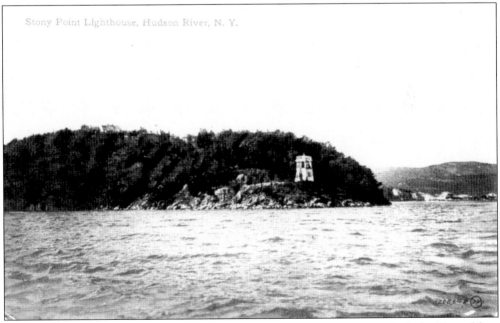

Stony Point Lighthouse, Hudson River, N. Y.

The Stony Point Lighthouse was restored in 1995. At that time, a Fourth Order Fresnel lens was once again installed in the lantern room, looking out on Haverstraw Bay and the Hudson Highlands. The lighthouse is now part of the Stony Point Battlefield State Historic Site, where an American attack on a British encampment took place July 15–16, 1779. American brigadier general Anthony Wayne won a medal for this successful battle.

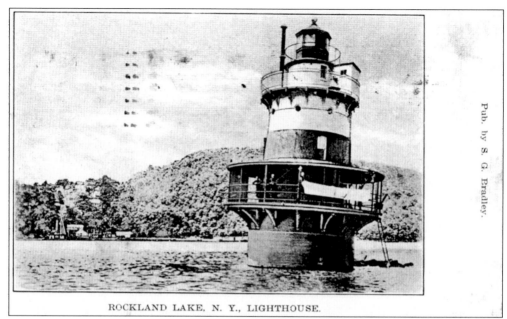

Pub. by S. G. Bradley.

ROCKLAND LAKE, N. Y., LIGHTHOUSE.

The cast-iron Rockland Lake Light was built in 1894. It was located on the west bank of the Hudson River, between Tarrytown and Stony Point. The base of the tower started to shift shortly after construction. The tower settled, with a permanent lean, in 1897. It was replaced by a skeleton tower in 1923.

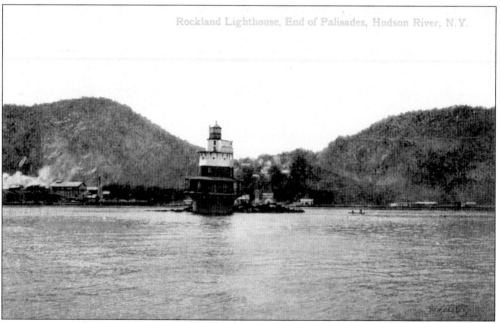

Rockland Lighthouse, End of Palisades, Hudson River, N.Y.

The first keeper of the Rockland Lake Light was Jonathan A. Miller, a Civil War veteran who had substantial experience as a lighthouse keeper. Miller had left his previous station, at Gardiner's Point, Long Island, earlier that year when that station succumbed to erosion and eventually fell into the water. The leaning tower at Rockland Lake was the second station in a row at which Miller had had an unstable foundation.

68

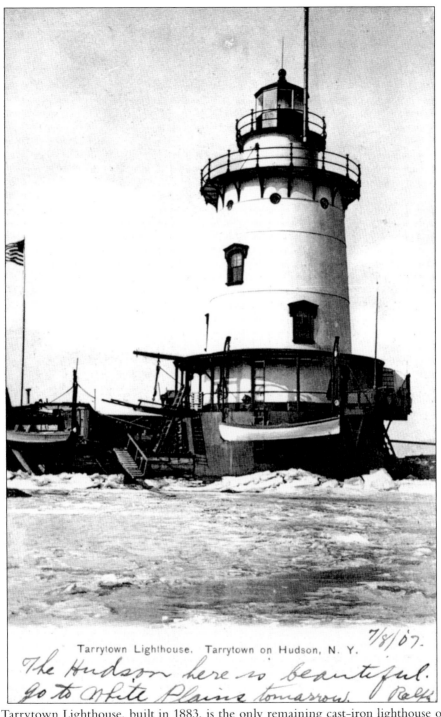

Tarrytown Lighthouse. Tarrytown on Hudson, N. Y.

7/8/07.

The Hudson here is beautiful. Go to White Plains tomorrow. Ralph

The Tarrytown Lighthouse, built in 1883, is the only remaining cast-iron lighthouse on the Hudson River. A lighthouse at Tarrytown Point was recommended by the Corps of Engineers as early as 1853, as there was "a very general wish on the part of those navigating the Hudson river" for a light in the area. The shoals on the east side of the Hudson River posed a particular problem at this site.

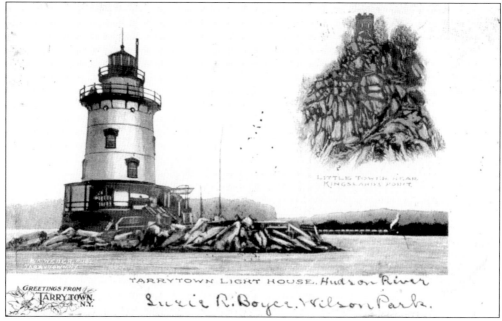

TARRYTOWN LIGHT HOUSE. Hudson River
GREETINGS FROM TARRYTOWN. N.Y.
Susie R. Boyer. Wilson Park.

A recurring theme in U.S. lighthouse history was the occasional difficulty encountered in obtaining land for lighthouses. This was a problem at Kingsland Point, as the cost of land at the desired site, which happened to be part of a successful vineyard, was considered excessive. By the time Congress appropriated funds for the project—$21,000 in 1881—an offshore site, one-quarter mile off Kingsland Point, had been selected.

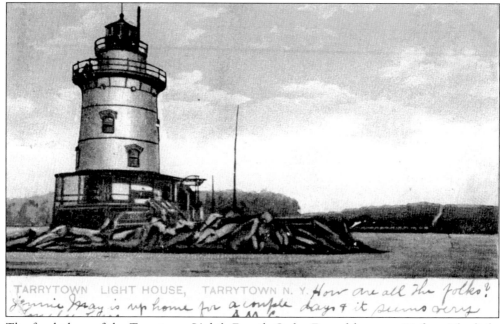

TARRYTOWN LIGHT HOUSE, TARRYTOWN N. Y. How are all the folks? Jennie May is up home for a couple days & it seems very

The focal plane of the Tarrytown Light's Fourth Order Fresnel lens was 56 feet. The light originally exhibited a fixed white characteristic. In 1902, the light was changed to a flashing red light. The station also had a fog bell, struck by machinery. The characteristic of one blow every 20 seconds had been changed to one blow every 30 seconds by 1907.

70

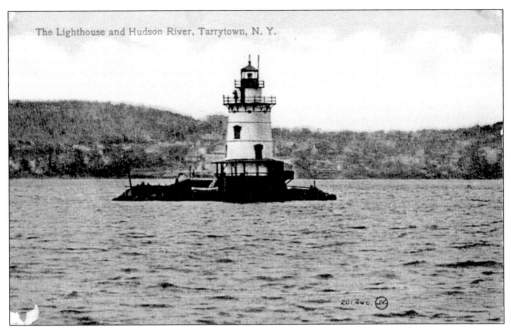

The Lighthouse and Hudson River, Tarrytown, N. Y.

Changes in the shoreline of the Hudson River have brought the Tarrytown Light closer to land. During the 1970s, a walkway was built between the shore and lighthouse. During the station's active years, the keeper and his family used a rowboat to go ashore. The walkway still stands and is still used to access the lighthouse from shore.

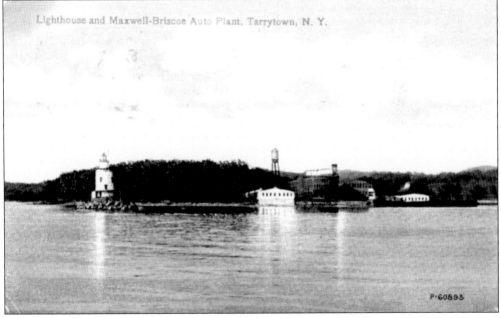

Lighthouse and Maxwell-Briscoe Auto Plant, Tarrytown, N. Y.

The Maxwell-Briscoe automobile plant, seen in the above postcard, opened in Tarrytown in 1904 to produce Maxwell cars. The plant, which had earlier produced Walker Steamer cars, produced 532 Maxwells that year, and Maxwells continued to be sold until 1925, not long after Walter Chrysler bought the company. The Maxwell Motor Company was succeeded by the Chrysler Corporation on June 6, 1925.

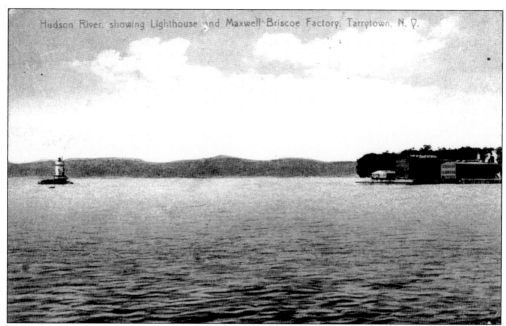

Hudson River, showing Lighthouse and Maxwell-Briscoe Factory, Tarrytown, N. Y.

The many lights on the Tappan Zee Bridge, which opened nearby in 1955, made the Tarrytown Light unnecessary. It was automated and its light decreased in 1957, it was then deactivated in 1961 and put up for sale by the federal government. Westchester County bought it in 1965 and made it part of their parks system.

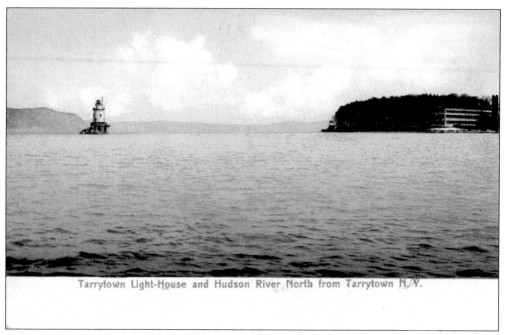

Tarrytown Light-House and Hudson River North from Tarrytown N. Y.

The Tarrytown Light was opened to the public on October 1, 1983, 100 years after it first went into public service. The lighthouse is now also called the 1883 Lighthouse at Sleepy Hollow. Today the Tarrytown Light serves as a museum and remains open to the public for tours by appointment, and includes period furniture, documents, and photographs.

Seven

NEW YORK HARBOR AND EAST RIVER

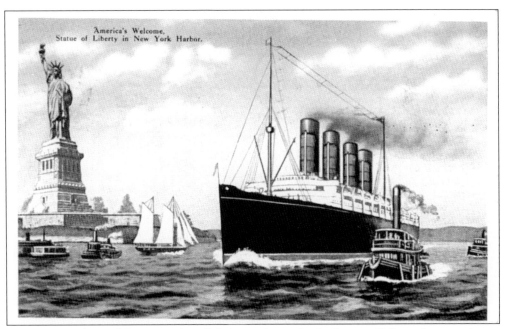

With perhaps the world's most unique lighthouse daymark, the Statue of Liberty has served as an aid to navigation, official or otherwise, since it was erected in 1886. It was an official lighthouse, administered by the Light-House Board, until 1902. While it was an active lighthouse, its electric light was in the flame part of the statue's torch, which reaches 305 feet into the air.

STATUE OF LIBERTY
NEW YORK CITY

The Statue of Liberty was intended as a gift from the French to celebrate the centennial of America's Declaration of Independence, but funding problems in France and in the United States (which would be responsible for building the base for the statue) caused the project to be completed 10 years late. Pres. Grover Cleveland was at the opening ceremony on October 28, 1886.

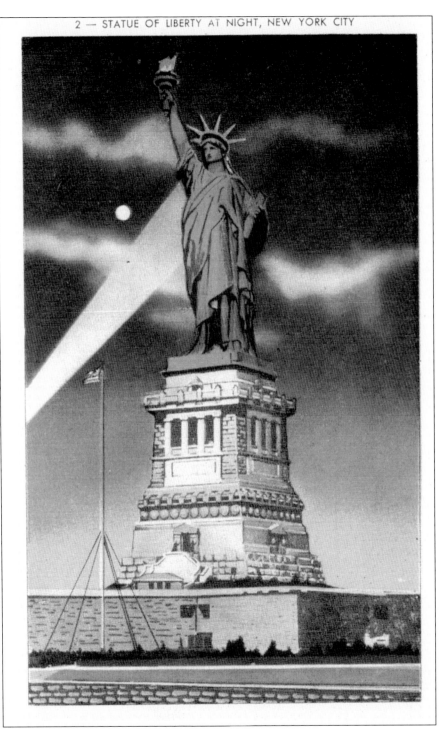

The Statue of Liberty reminds many people of the *Colossus of Rhodes*. The *Colossus*, one of the Seven Wonders of the Ancient World, was a statue of the Greek god Helios that stood on the island of Rhodes. Completed in 282 B.C., after 12 years of construction, the *Colossus* was nearly the same size as the Statue of Liberty, also held a torch aloft, and was built to celebrate freedom.

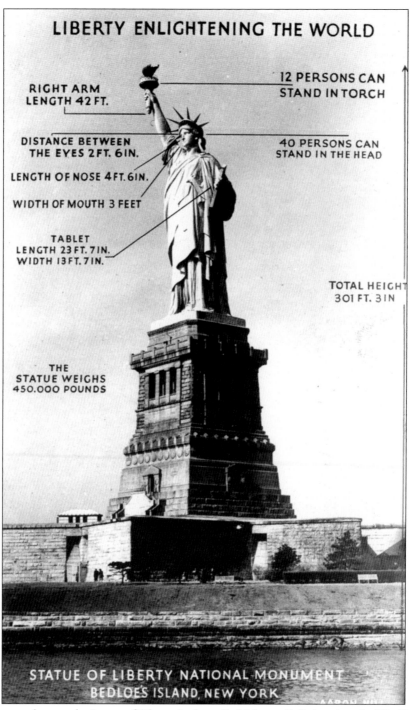

LIBERTY ENLIGHTENING THE WORLD

RIGHT ARM LENGTH 42 FT.

12 PERSONS CAN STAND IN TORCH

DISTANCE BETWEEN THE EYES 2 FT. 6 IN.

40 PERSONS CAN STAND IN THE HEAD

LENGTH OF NOSE 4 FT. 6 IN.

WIDTH OF MOUTH 3 FEET

TABLET LENGTH 23 FT. 7 IN. WIDTH 13 FT. 7 IN.

TOTAL HEIGHT 301 FT. 3 IN

THE STATUE WEIGHS 450.000 POUNDS

STATUE OF LIBERTY NATIONAL MONUMENT BEDLOES ISLAND, NEW YORK

As this postcard notes, the Statue of Liberty is also called Liberty Enlightening the World. In fact, this is the name that appears on Lighthouse Service charts during the statue's years as an official aid to navigation. One of the Americans involved in the building of the base of the statue was Francis Hopkinson Smith, a famous engineer, painter, and author, whose other projects included the Race Rock, New York, and Bedford Flats, Rhode Island, lighthouses.

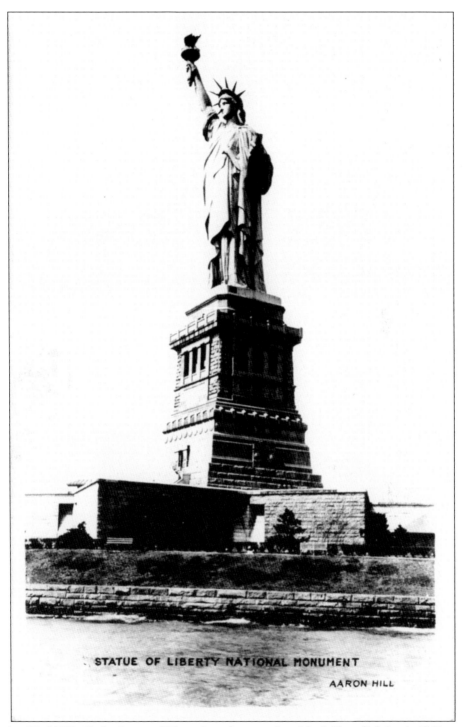

STATUE OF LIBERTY NATIONAL MONUMENT

AARON HILL

During World War II, the Statue of Liberty's torch was extinguished. Her relighting in 1945 created an emotional moment for war veterans recovering in a military hospital at nearby Governor's Island, in view of the statue and her torch. They gathered by windows, some of them pushed in wheelchairs to the spot, to see the torch of liberty relit after America's wartime involvement.

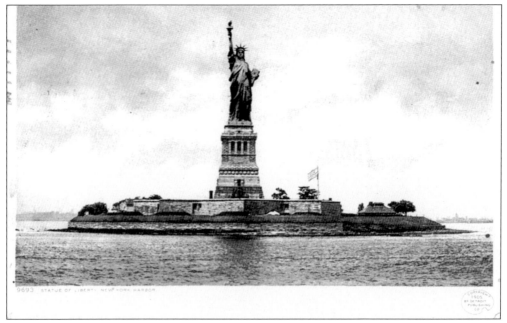

This postcard, postmarked 1907, shows the entire island on which the Statue of Liberty was built. It was originally named Bedloe's Island, after Isaack Bedloo, who owned the island in the mid-1600s. The island's name was changed to Liberty Island in 1956. The star-shaped walls around the statue's base are from Fort Wood, a fort built on the island between 1806 and 1811.

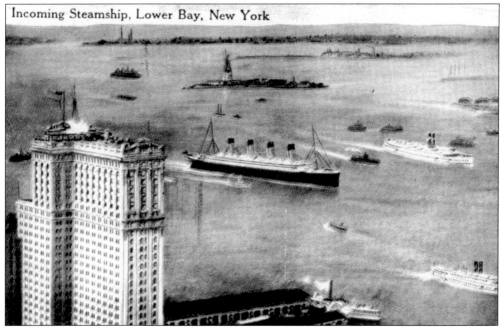

This view of the Statue of Liberty and harbor from lower Manhattan bears the following on the back: "Incoming Steamships, Lower Bay. The Port of New York is the busiest in the world, the yearly traffic exceeding 150,000,000 tons. One hundred and fifty-five steamship lines focus here, including the most powerful in the world."

RCA BLDG., Rockefeller Center STATUE OF LIBERTY EMPIRE STATE BLDG. New York City 4

The Statue of Liberty remains a popular tourist attraction, as well as a grand architectural example. The site includes a 1986 exhibit on the second floor of the pedestal tracing the statue's history and symbolism, and an exhibit on the statue's original torch. Several tours are available at the site, but the crown and torch are not open to the public.

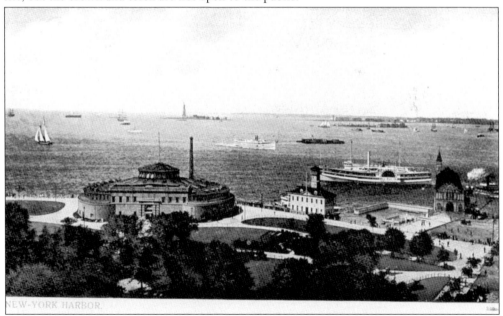

NEW-YORK HARBOR.

This postcard shows the view of the Statue of Liberty from behind the New York Aquarium. The aquarium was built in 1896 in the part of Manhattan now known as Battery Park. The proposed building of a bridge caused the closing of the aquarium in 1941. Its specimens were kept at the Bronx Zoo until a new aquarium could be built. The aquarium reopened on Coney Island in 1957.

79

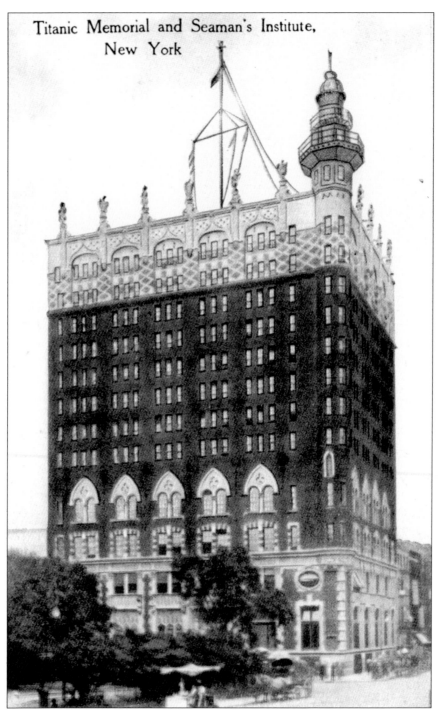

Titanic Memorial and Seaman's Institute, New York

The Titanic Memorial Light was constructed in 1913 and put on top of the Old Seaman's Church Institute overlooking the East River, as seen in this postcard. In addition to the light, the tower originally included a ball that dropped on its pole each day at noon, to signal the time to ships. In 1965, the tower was donated to the nearby South Street Seaport Museum. It has been at its present location, at the entrance to the museum, since 1976.

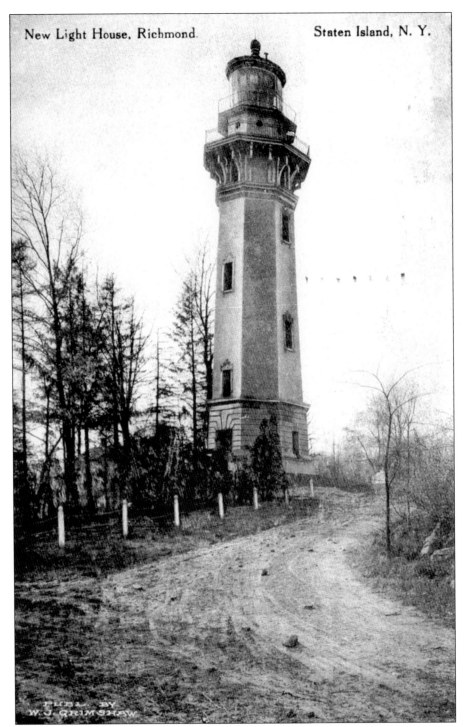

New Light House. Richmond. Staten Island, N. Y.

PUBL. BY
W. J. GRIMSHAW

The Staten Island Light was built as a rear range light, with the offshore West Bank Light acting as the front light. Congressional acts in 1906 and 1909 appropriated money for the project (the West Bank Light already existed, but needed to be raised). The Staten Island Light was built on Richmond Hill, now called Lighthouse Hill, and held its light 231 feet above sea level.

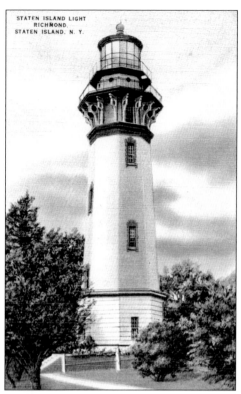

The Staten Island Light was completed and first lit on April 15, 1912. When built, the light-colored brick tower housed a Second Order Fresnel range lens made by the British company Chance Brothers. Originally lit with an incandescent oil vapor (IOV) lamp, the light was electrified in 1939. The lighthouse remains in service, but the keeper's dwelling is a private residence.

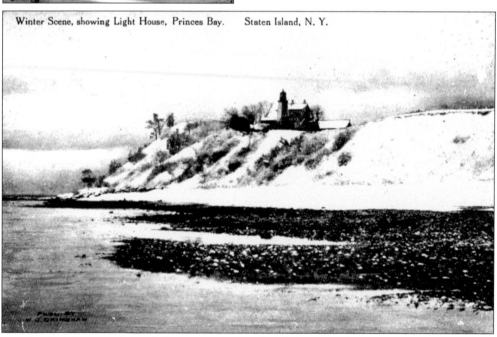

Winter Scene, showing Light House, Princes Bay. Staten Island, N. Y.

The first lighthouse at Prince's Bay (sometimes called Princess Bay), Staten Island, was built in 1828. It was replaced by a new brownstone tower in 1864, and received a new two-and-a-half-story dwelling in 1868. This station was important to the vibrant oyster industry in the area for many years. It was decommissioned in 1922.

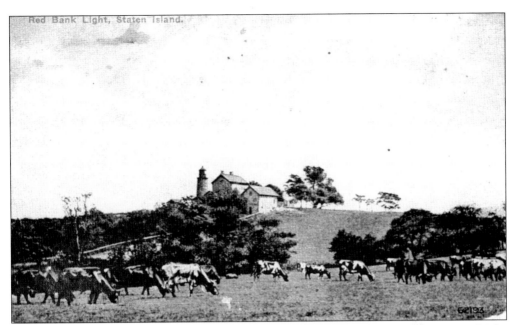

The bluff at Prince's Bay has been called Red Bank, hence the station's name on this postcard. The hill the lighthouse sits atop has also been called Lighthouse Hill (for obvious reasons) and Seguine's Hill. The lighthouse cast its light, overlooking Raritan Bay, from a height of 106 feet. Initially lit by 12 lamps with 14-inch reflectors, the station was refitted with a Third-and-One-Half Order Fresnel lens in 1857.

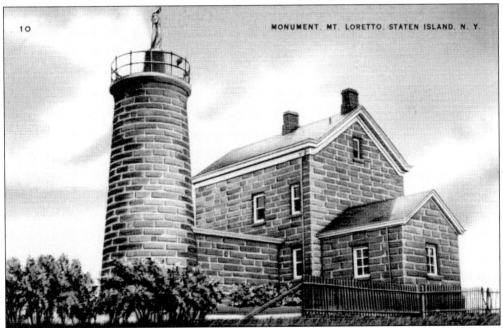

MONUMENT, MT. LORETTO, STATEN ISLAND, N. Y.

After being decommissioned, the Prince's Bay Light was used as a Catholic children's home. The lantern room was replaced with a statue of the Virgin Mary, as seen on this postcard. Today the lighthouse is part of Mount Loretto Unique Area, a nature preserve that features trails and nesting birds. A small skeletal light also occupies the site.

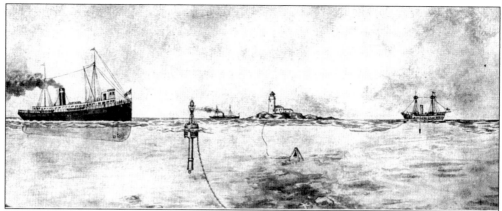

This postcard of a "Submarine Fog Signal N.Y. Harbor" includes two steamships, a lighthouse, and a lightship. The hull of the lightship identifies it as the *Ambrose Channel*. This ship's designation was *LV 87*. It served at Ambrose Channel from 1907 to 1932, and is currently on display at the South Street Seaport Museum. The lighthouse on the card is the Sandy Hook, New Jersey, Light.

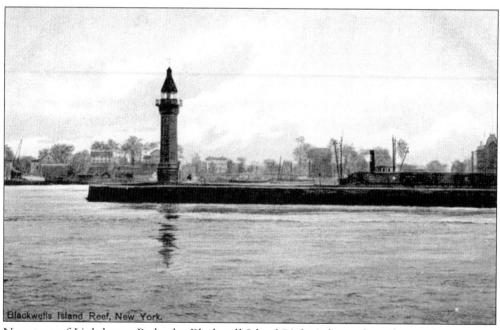

Blackwells Island Reef, New York.

Now part of Lighthouse Park, the Blackwell Island Light is located on the northern end of present-day Roosevelt Island in the East River. The 50-foot stone tower was built in 1872, reportedly with help from inmates from the local prison. The prison was closed in 1935 when the Riker's Island prison opened. The tower was decommissioned in the 1940s, and underwent a major restoration in the late 1990s.

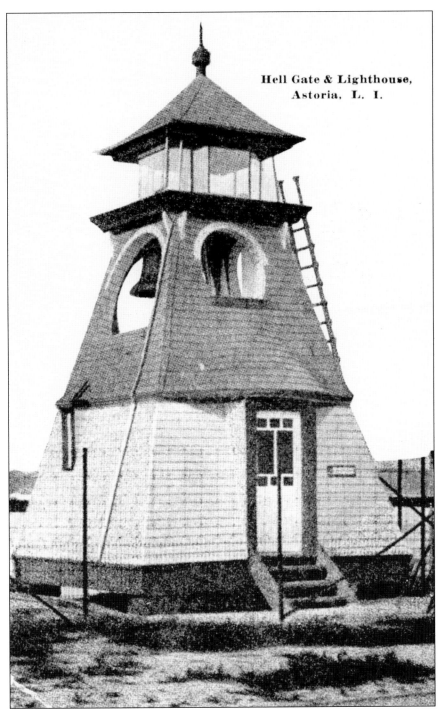

Hell Gate & Lighthouse,
Astoria, L. I.

The part of the East River known as Hell Gate, or Hurl Gate, has a long history of creating problems for mariners. Blasting of some submerged rocks helped, but more was needed in the late 19th century to aid the increasing traffic. An experimental electric light was tried from 1883 to 1886, but its unreliability led to its removal in 1886 and replacement with the pictured tower in 1889.

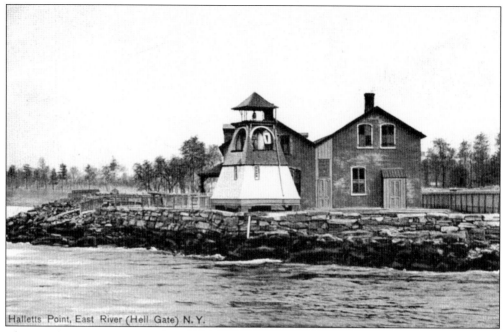

Halletts Point, East River (Hell Gate) N.Y.

The wooden 1889 tower at Hell Gate was designed by David Porter Heap, one of the nation's most respected lighthouse engineers. The small wooden tower incorporated an oil lamp and a fog bell. This light was eventually torn down and replaced with a small, automated skeletal light.

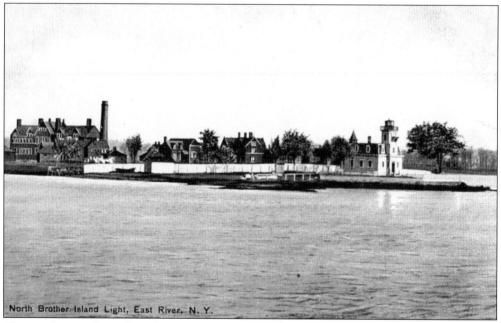

North Brother Island Light, East River, N.Y.

The wooden North Brother Island Light served East River mariners from 1869 to 1953. Originally equipped with a Sixth Order Fresnel lens, the lighthouse was updated with a Fourth Order lens in 1900. Only ruins remain of this lighthouse. North Brother Island has also been the site of a contagious disease hospital (including its most famous occupant, Typhoid Mary) and a center for troubled teens. The island is now abandoned, except for many nesting birds.

Eight

LONG ISLAND SOUND, FISHER'S ISLAND SOUND, AND GARDINER'S BAY

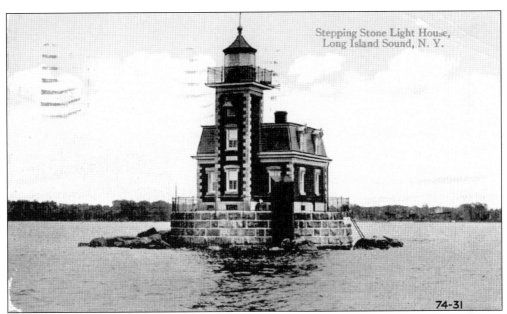

This postcard, postmarked August 15, 1924, shows the Stepping Stones Light. It was constructed on one of several shallow areas known by early inhabitants as the Devil's Stepping Stones. According to the associated legend, the devil had been chased from what is now Westchester County to Long Island and used these shallow areas to make the crossing.

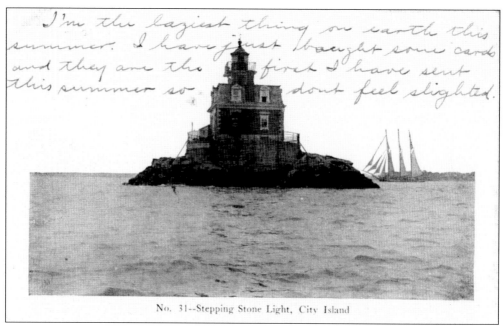

I'm the laziest thing on earth this summer. I have just bought some cards and they are the _____ first I have sent this summer so _____ dont feel slighted.

No. 31--Stepping Stone Light, City Island

The Stepping Stones Light was originally intended to be built on nearby Hart Island, but multiple difficulties with the site, including erosion and the high price of the land, eventually caused the Lighthouse Service to look elsewhere. Keeper Findlay Fraser lit the Stepping Stones Light for the first time on March 1, 1877. The light's characteristic was a steady red light, emitted from a Fifth Order Fresnel lens.

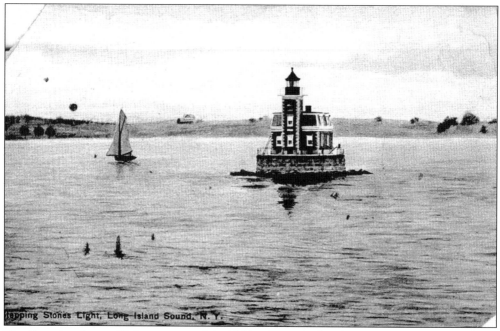

Stepping Stones Light, Long Island Sound, N.Y.

The Stepping Stones Light, automated in 1964, still serves local mariners in the west end of Long Island Sound, emitting a flashing green light at night. The lighthouse is easily seen from the Throgg's Neck Bridge and City Island. The old fog bell no longer resides at the station.

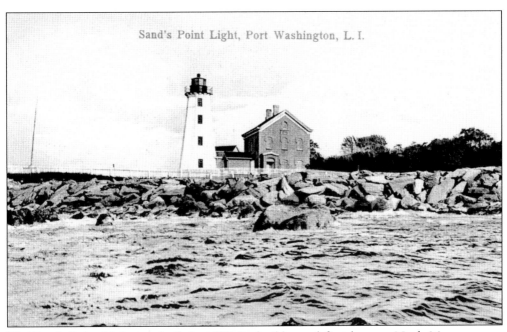

The Sands Point Light was built in 1809. Its builder and first keeper, Noah Mason, was a Revolutionary War veteran. A War of 1812 naval battle took place in the Long Island Sound off Sands Point while Mason was keeper. He remained at the station until he passed away in 1841 at the age of 85.

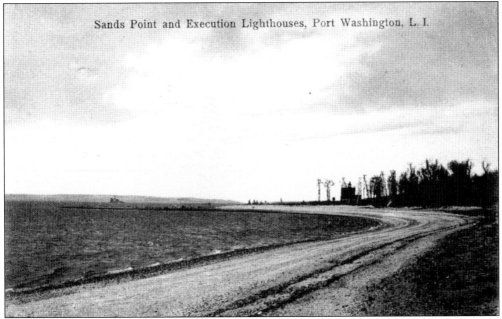

Sands Point and Execution Lighthouses, Port Washington, L. I.

Both the Sands Point Light, on the right third of this postcard, and Execution Rocks Light, on the left third, are visible in this postcard, postmarked 1910. The Sands Point Light served until 1922, when it was replaced by an acetylene light on a pier off the point. The property was bought at auction by noted feminist Alva E. Belmont, who later sold it to William Randolph Hearst. The property remains privately owned, and the lighthouse and 1867 keeper's dwelling still stand.

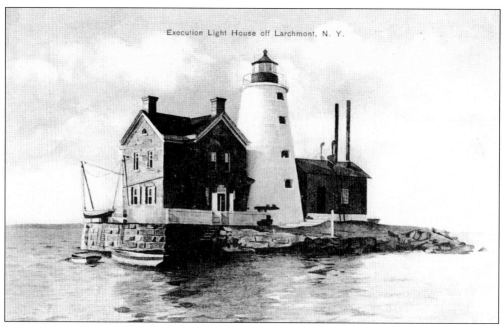

Execution Light House off Larchmont, N. Y.

The Execution Rocks Light was completed in 1850. At first, assistant keepers from the nearby Sands Point Light rowed out to the offshore light to maintain it. The keeper's quarters, left of the tower, were added in 1867. This postcard shows the tower prior to the addition of a brown stripe in 1899.

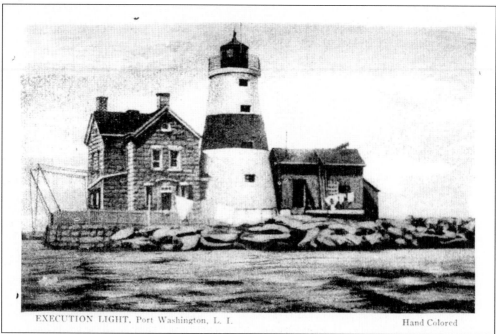

EXECUTION LIGHT, Port Washington, L. I. Hand Colored

The name Execution Rocks comes from the fact that the rocks were a danger to shipping, but local folklore often assigns the name to the execution of American rebels by the British by chaining them to the rocks at low water and allowing the tide to drown them. Another version of this tale blames Native Americans for the grisly act.

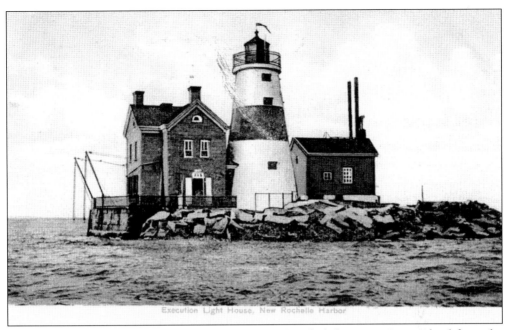

Execution Light House, New Rochelle Harbor

The Execution Rocks Light remains the only standing lighthouse on Long Island from the 1820 to 1852 period, when the fifth auditor of the treasury, Stephen Pleasanton, ran the nation's lighthouse system. The 1891 fog signal building to the right of the tower in the above image was lost to a fire in 1918.

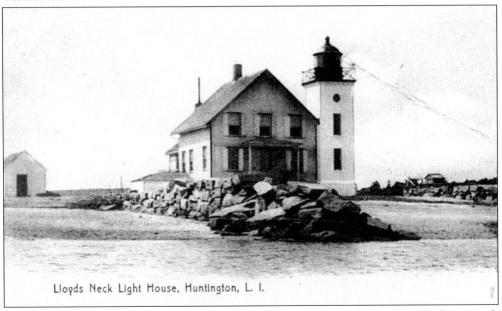

Lloyds Neck Light House, Huntington, L. I.

The first Lloyd Harbor Light was built in 1857 at the end of a sand spit to guide ships to safe harbor. By about 1900, Huntington Harbor, adjacent to Lloyd Harbor, had become the more important harbor. A new offshore lighthouse was built between the two harbors in 1912. The original lighthouse burned in 1947; its 1912 replacement still serves as an active aid to navigation and has been the subject of a preservation effort by the Huntington Lighthouse Preservation Society since 1985.

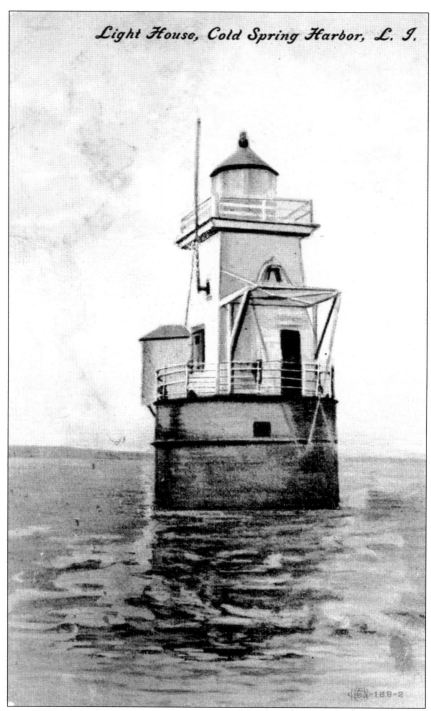

Light House, Cold Spring Harbor, L. I.

The Cold Spring Harbor Light was built in 1890 on the end of a muddy shoal between Centre Island and Lloyd Neck. Pres. Teddy Roosevelt was known to row out to the light with family members from his home on nearby Sagamore Hill and visit keeper Arthur Jensen. Its wooden tower was removed from the cast-iron caisson base in 1965 to be demolished, but a local resident purchased it for $1 and it still resides on private property.

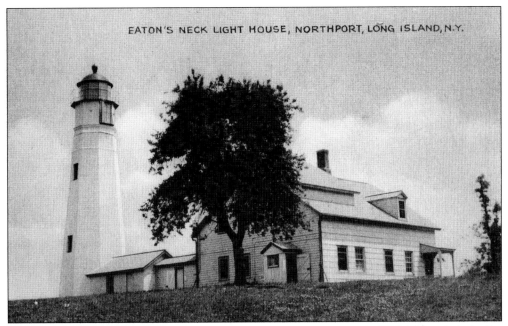

The Eaton's Neck Light has been in continuous service since January 1, 1799. The style is similar to the Montauk Point Lighthouse; this is no coincidence. The Eaton's Neck tower was built by John McComb Jr., a Scottish immigrant who also built the Montauk Point Light; the Cape Henry, Virginia, Light; and other important structures.

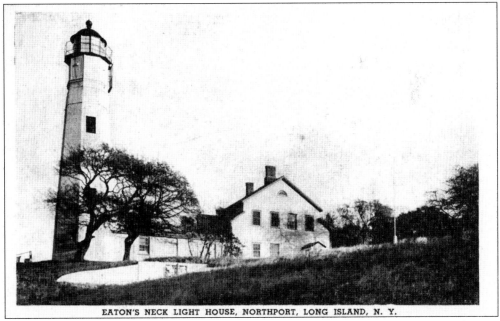

EATON'S NECK LIGHT HOUSE, NORTHPORT, LONG ISLAND, N. Y.

In March 1798, Congress authorized $13,250 for the construction of the Eaton's Neck Light. Ten acres were bought from John and Joanna Gardiner in June, shortly before McComb submitted his proposal, and Pres. John Adams signed the order designating the site on July 2. The lighthouse was completed and lit in less than five months.

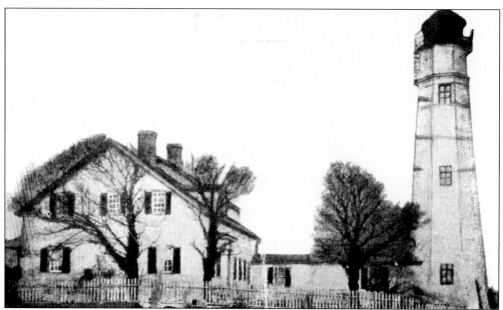

The original Eaton's Neck keeper's dwelling, built by McComb, was one-and-one-half stories tall. This was later replaced by the quarters seen above. The tower, as proposed, began about eight feet below ground, where the walls were seven feet thick and 24 feet in diameter, and climbed 50 feet above ground, where the walls were two feet thick and ten feet, six inches in diameter. The tower, now white, was originally painted in vertical black and white stripes.

Atop the 50-foot stone tower built at Eaton's Neck in 1798 sat an octagonal lantern room using four copper lamps of 12-quart capacity each. The cost for the tower, lantern, lamps, and dwelling was approximately $9,750. The tower was modified in the 1850s, making the tower taller and replacing McComb's lantern, to accept a Third Order Fresnel lens from Paris. This is the way the tower appears now.

94

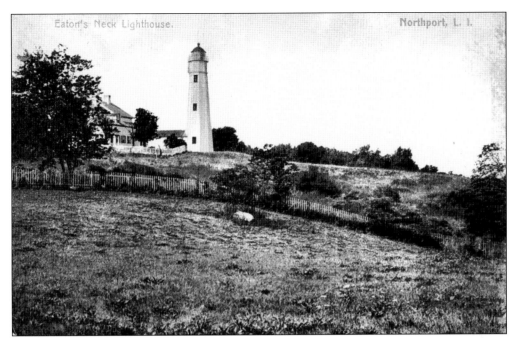

The Eaton's Neck Light was established to address the great number of shipwrecks occurring nearby in the Long Island Sound. This remained a problem, although to a lesser extent, after the building of the lighthouse. In 1849, to further assist mariners in distress, the site became home to Long Island's first Life Saving Station.

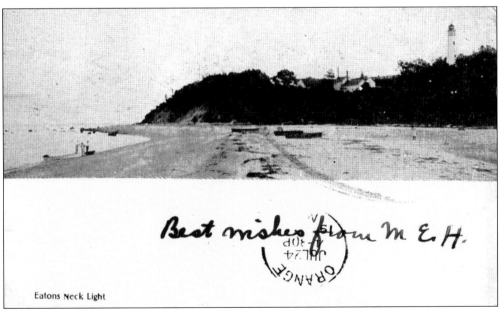

Eatons Neck Light

Best wishes from M E. H.

The Eaton's Neck tower still houses its 1850s Third Order Fresnel lens, but lacks its former keeper's quarters, which were torn down in 1969. An 1898 fog bell is also on display at the site. It remains an active U.S. Coast Guard station, serving mariners in Huntington Bay and Long Island Sound. Decreased federal funding and erosion of the bluff upon which the lighthouse sits are the main threats to the structure.

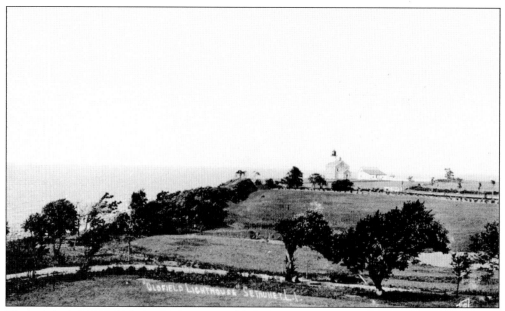

The original Old Field Point Light was established in 1824. It was replaced by the lighthouse seen in these postcards in 1869. This station is located west of Port Jefferson Harbor, where shipbuilding was an important industry in the 1800s. As many as 12 shipyards existed at a time, turning out over 325 wooden ships. Since 1872, the port has been home to a ferry service to Bridgeport, Connecticut.

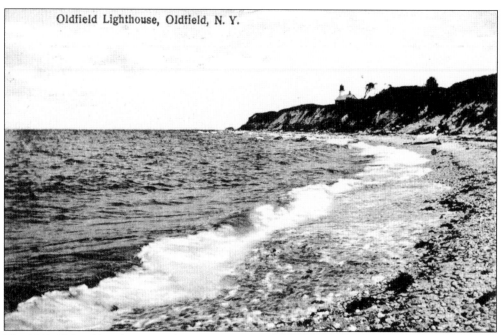

The 1869 Old Field Light is one of six nearly identical lights built in the Third Lighthouse District between 1867 and 1870. These structures are built of granite blocks with a cast-iron tower. The tower at Old Field has "1868" cast on the front of it, indicating the year the tower was made. The lighthouse was not put together on-site, however, until the following year.

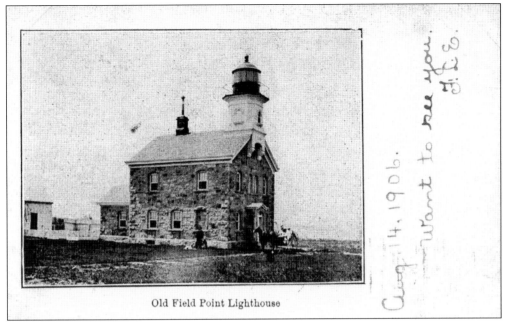

Old Field Point Lighthouse

The Old Field Point Light Station is perhaps best known for having had several female head keepers. The first was Mrs. Edward Shoemaker, wife of the light's first keeper, who gained the job upon her husband's death in 1826. Walter Smith became the next keeper in 1827, but he also died while assigned to the station. His wife, Elizabeth, became head keeper, keeping the post for more than 25 years. Mary Foster was the next keeper, serving from 1856 to 1869.

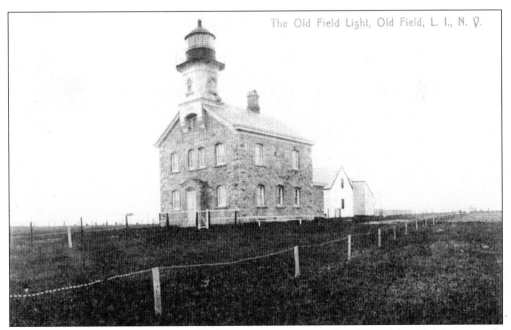

The Old Field Light, Old Field, L. I., N. Y.

The cast-iron tower of the Old Field Point Light was originally white, although it is currently black. Photographs taken from the angle used in the above postcard are no longer possible because of erosion of the bluff on which the lighthouse is situated.

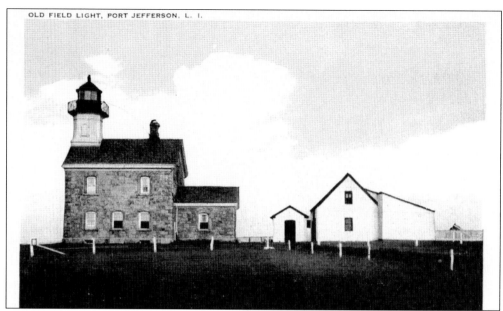

The Old Field Point Light was replaced by an automated light on a skeleton tower in 1933. In 1935, Congress authorized the transfer of the site to the Village of Old Field, which still uses it. The station has remained an active aid to navigation, and a new light was put in the 1869 tower in 1991. A 1902 oil house and the original 1824 keeper's quarters also remain on the site (both are seen in this image).

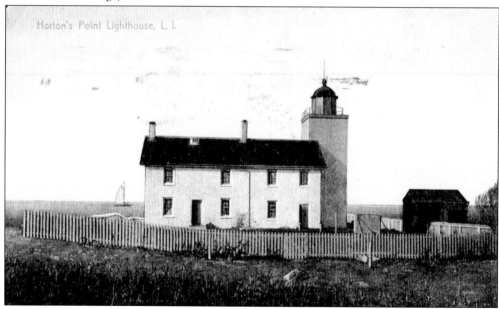

Horton's Point Lighthouse, L. I.

The Horton Point Light Station was established in 1857, approximately 100 years after Col. George Washington is reported to have first discussed the need for a lighthouse while visiting the site. When Washington became the president of the United States, he tried to have a lighthouse built at Horton Point, but the Horton family, which had owned the land since settlement of the area in 1640, did not want to sell the property. It did not become available to the government until 1855.

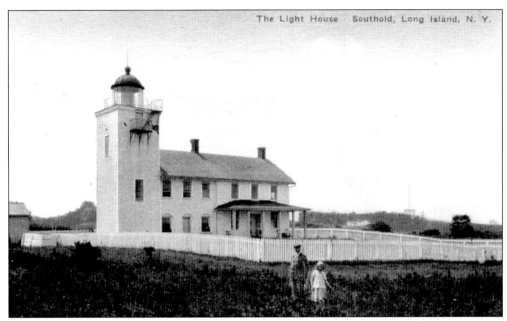

The Horton Point station was considered a good duty. The lighthouse's location near schools and other important facilities, as well as its scenic location high on a bluff, made it an excellent place for a keeper's family. One keeper who raised a family here was George Ehrhardt, the station's last keeper. George's daughter, Marguerite, remained in the area and helped direct the eventual restoration of the Horton Point Light.

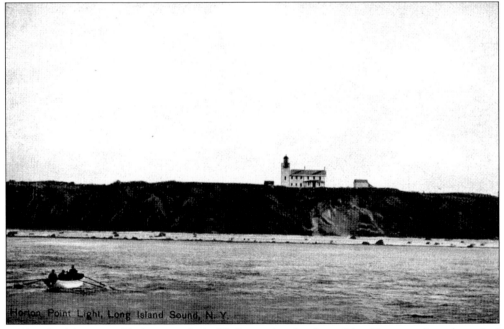

Horton Point Light, Long Island Sound, N. Y.

Evident in this postcard is the great deal of deforestation that Long Island has seen since the arrival of Europeans. Long Island's forests were used for building and fuel on Long Island, in New York City, and elsewhere. Today the Horton Point Lighthouse site, despite the encroachment of private residences, is populated with many trees, brush, and wildlife, and also includes a nature trail.

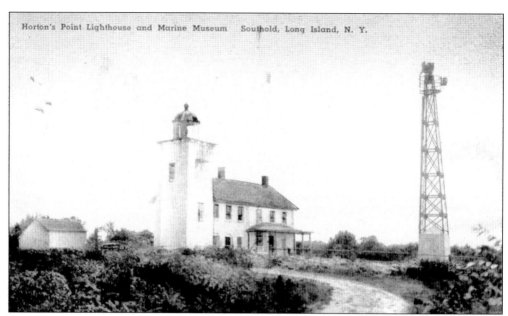

The lamp and lens inside the Horton Point Light's tower were removed in 1933. An automated light atop a steel skeleton tower became the station's aid to navigation. The tower remained dark until 1990, when the lighthouse was relit as part of a restoration effort. Today a flagpole sits atop the base of the 1933 skeleton tower, and the lighthouse works as an aid to navigation and a maritime museum.

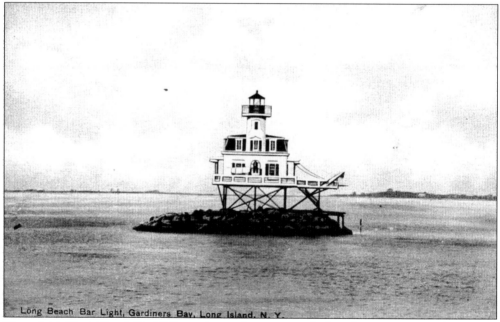

Long Beach Bar Light, Gardiners Bay, Long Island, N. Y.

The original Long Beach Bar Light was erected on a screwpile foundation, as seen in this image. With this type of foundation, metal piles are screwed into the seabed, then braced, and the lighthouse itself sits upon this foundation. It was not a common type of foundation in northern regions, due to its susceptibility to damage from ice floes. This was proven at Long Beach Bar several times, although the damage was always reparable.

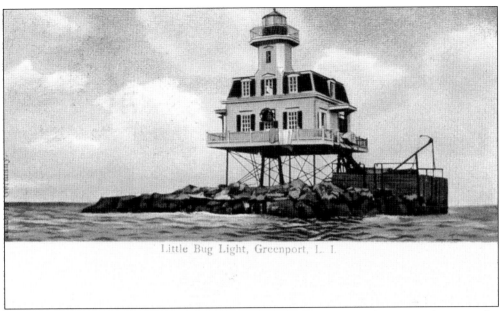

Little Bug Light, Greenport, L. I.

As noted on this postcard, the Long Beach Light has sometimes been called the Little Bug Light, or just Bug Light, perhaps due to its appearance standing in the water on spindly legs. The landing wharf at the site was rebuilt several times because of ice damage. Comparing this image to the previous one shows the construction of a stronger landing.

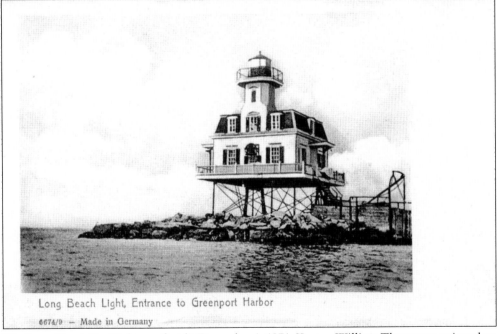

Long Beach Light, Entrance to Greenport Harbor

6674/9 — Made in Germany

The Long Beach Bar Light was first lit December 1, 1871. Keeper William Thompson resigned on December 22, but remained on until April 18, 1872, when his replacement arrived. In February and March, while waiting to be relieved of duty at Long Beach Bar, Thompson and his assistant endured some assaults by ice floes. The March ice was so bad that the keepers abandoned the station for two nights.

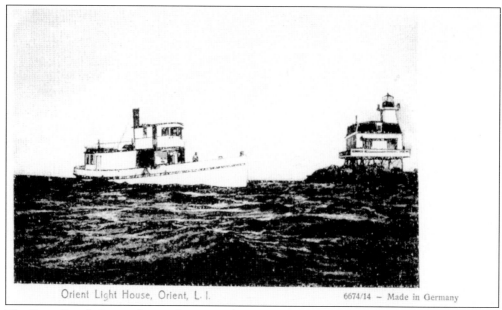

Orient Light House, Orient, L. I. 6674/14 — Made in Germany

The Long Beach Bar Light was located at the end of a long sand spit (now a state park) that originates in the town of Orient. This has led to it sometimes being called the Orient Lighthouse. With another lighthouse located at nearby Orient Point, this misnomer has the potential to cause confusion. The Long Beach Bar Light is usually associated with the port of Greenport, as it aids mariners entering or departing Greenport via Gardiner's Bay.

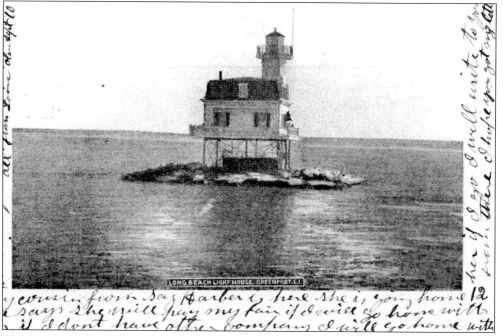

LONG BEACH LIGHT HOUSE, GREENPORT, L. I.

The area under the Long Beach Bar Light, within its pilings and framework, would attract fish and shellfish. These sea creatures frequenting the water within the rocks were easy prey. Keepers, who generally sought ways to supplement their provisions and income, would take advantage of this fortunate fact.

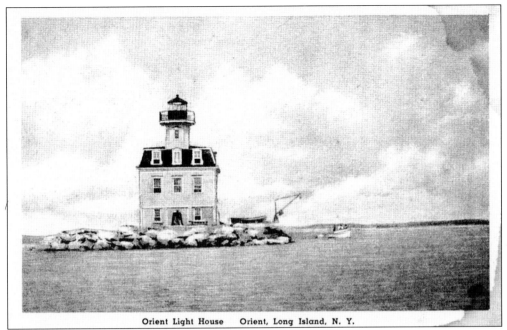

Orient Light House Orient, Long Island, N. Y.

Long Beach Bar's screwpile foundation was replaced with reinforced concrete in 1926 to facilitate the installation of a central steam heating system. The light was decommissioned in the 1940s, auctioned off by the federal government in the 1950s, and burned by arsonists on July 4, 1963. A plywood and vinyl-siding replica now occupies the old lighthouse's offshore site.

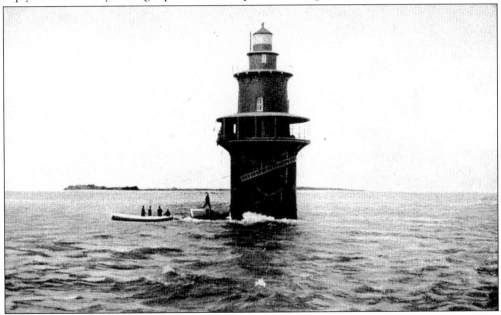

The Orient Point Light sits off the northeast tip of Long Island, guarding the west side of a tricky waterway called Plum Gut. It was established in 1899. The lighthouse's prefabricated cast-iron construction allowed it to be completed in one season. Its original red Fifth Order Fresnel light, first lit on November 10, 1899, proved too dim and was replaced the following May with a stronger optic.

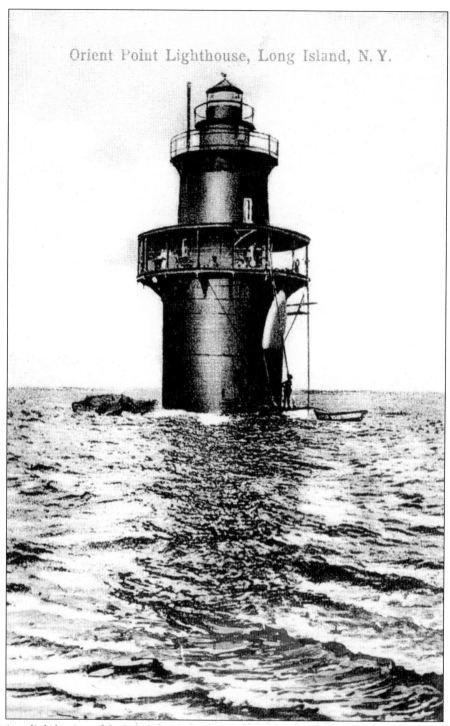

Orient Point Lighthouse, Long Island, N. Y.

Cast-iron lighthouses of the type used at Orient Point were often called spark plug–style lights, the reason for which is obvious in the above postcard. The Orient Point Light's construction and drab brown color gained it the nickname of the Coffee Pot. It retains this nickname, even though its appearance has changed with time.

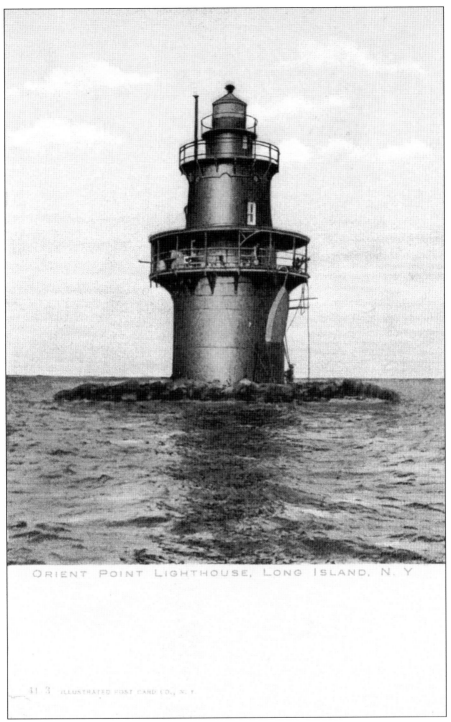

ORIENT POINT LIGHTHOUSE, LONG ISLAND, N. Y.

11 3 ILLUSTRATED POST CARD CO., N. Y.

To protect the Orient Point Lighthouse from ice, riprap was placed around the base of the tower beginning in 1902. Nearly 10,000 tons of rocks were used in the project, which lasted until May 1903. During this period, the station used a siren as a fog signal. This was changed to a Daboll trumpet in 1905.

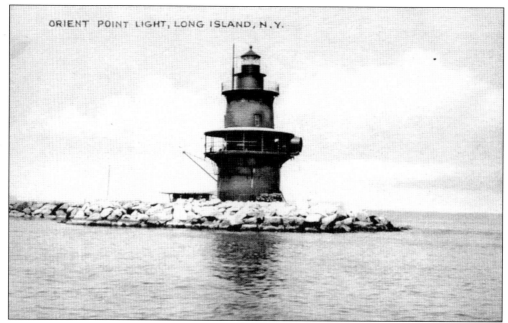

ORIENT POINT LIGHT, LONG ISLAND, N.Y.

In the 1920s, a lighthouse romance took place between the Orient Point and Plum Island lighthouses. An assistant keeper at Orient Point fell in love with one of the daughters of the Plum Island keeper. They later married and moved up island. Descendants of this lighthouse family still live on Long Island and support lighthouse preservation.

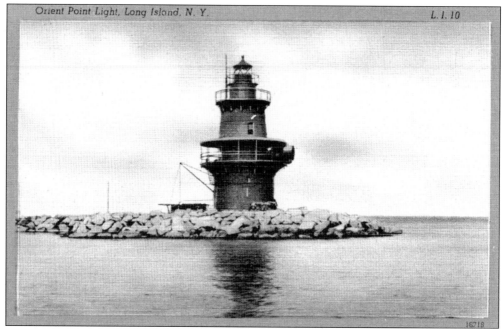

Orient Point Light, Long Island, N. Y. L. I. 10

The Orient Point Light was fully automated in 1958 and its last keeper was transferred across Plum Gut to the Plum Island Light. The cramped, round quarters at Orient Point did not make for a good duty; a report on the removal of the last keeper stated that he "expressed no regret when he hauled down the flag" and ended the lighthouse's years of human habitation.

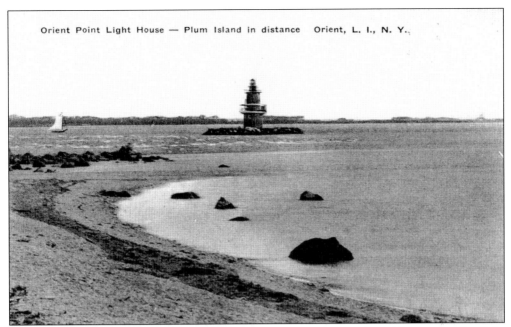

Orient Point Light House — Plum Island in distance Orient, L. I., N. Y.

A plan to demolish the Orient Point Light in the early 1970s caused a public outcry. The light was not only kept in service, but was painted. The lighthouse remains in service, with a flashing white light. It is now without its covered gallery, is painted black with a white band, and has large solar panels.

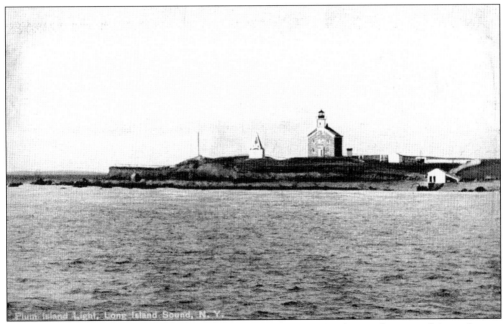

Plum Island Light, Long Island Sound, N. Y.

The Plum Island Light Station was established in 1827. The light shown above, with its no longer extant fog bell tower, replaced the original tower in 1869. During the early 1900s, the island was also home to Fort Terry, one of five area forts established during the Spanish-American War.

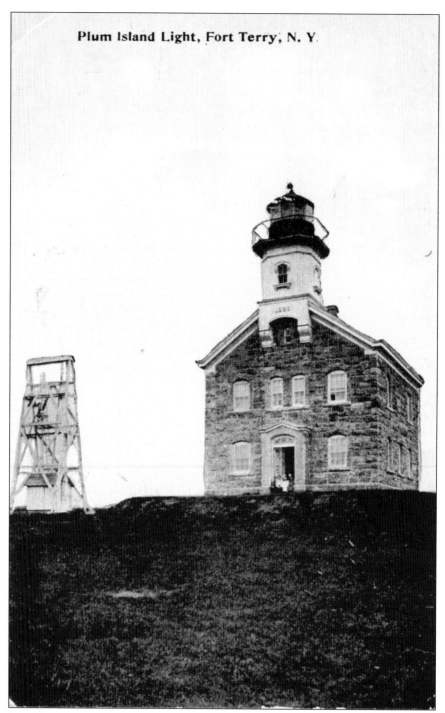

Plum Island Light, Fort Terry, N. Y.

The Plum Island Light was decommissioned in 1978 and turned over to the U.S. Department of Agriculture (USDA), which allowed it to deteriorate. The abandoned lighthouse, now under the Department of Homeland Security, has been the subject of preservation efforts by the Long Island Chapter of the U.S. Lighthouse Society. Its eroded bluff has been stabilized by an effort that included the lighthouse society, USDA, Homeland Security, and others.

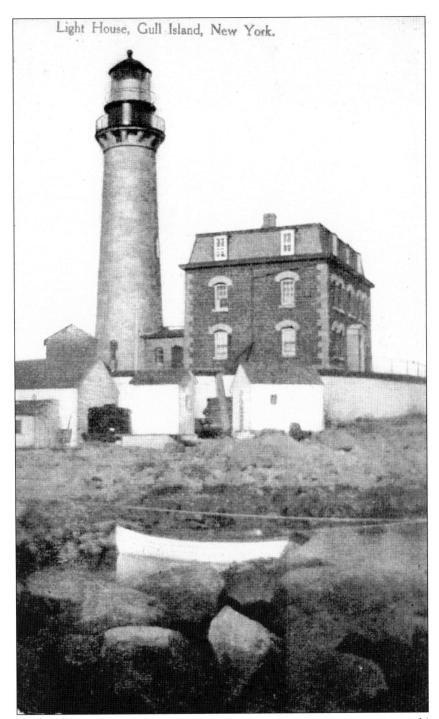

Light House, Gull Island, New York.

The granite 1869 lighthouse at Little Gull Island replaced a stone tower constructed in 1806. The island, and adjacent Great Gull Island, was named after the many terns—called fish gulls at the time—that nested on the islands. The tiny island and its lighthouse keepers have been hit hard by weather many times, most notably during the September hurricanes of 1815 and 1938, but no lives were lost at Little Gull Island in either of these horrible storms.

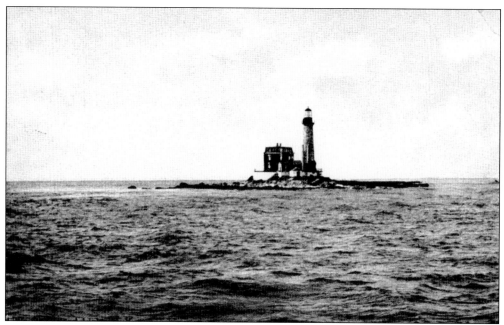

At approximately 90 feet tall, the Little Gull Island Light is one of the tallest lighthouses in New York. The station's keeper's quarters, seen on this postcard, burned in 1944. The tower's old Second Order Fresnel lens is now on display at the East End Seaport Museum in Greenport.

Fisher's Island Light House, LONG ISLAND, Sound. 10589

The Race Rock Light, and the dangerous rocky ledge for which it is named, sits about three-quarters of a mile off the west end of Fisher's Island, on the east side of a waterway called the Race. This area gained its name for the rapid currents that occur during tide changes, as a great deal of water is exchanged between the Long Island Sound and Block Island Sound.

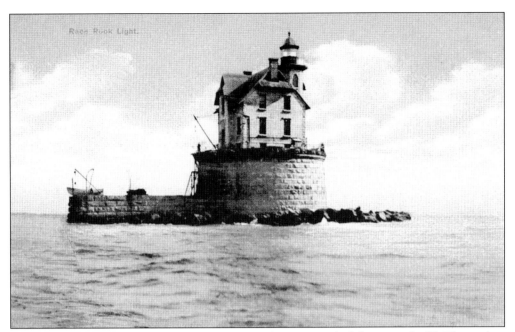

The Race Rock Light was one of the most difficult American lighthouses to build. The project began in 1870 but was not completed until 1879. The strong tides and often nasty weather cost several lives and over $278,000. Most of the work consisted of creating a stable surface underwater on which to build the pier and lighthouse.

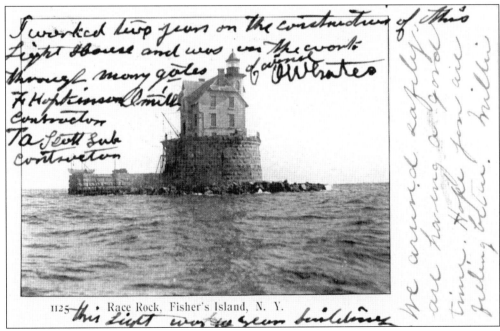

A note on this postcard of Race Rock, signed by A. W. Gates, states that "I worked two years on the construction of this lighthouse and was on the work through many gales of wind." Gates also notes that F. Hopkinson Smith and T. A. Scott were in charge of the project that "was 10 years building."

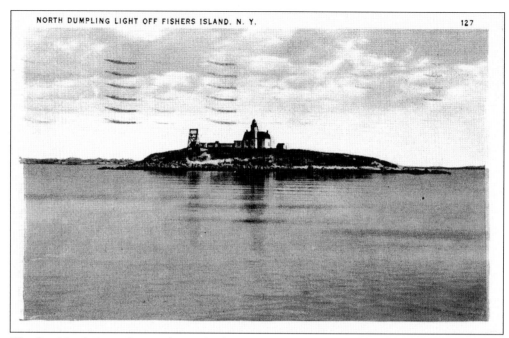

The first North Dumpling Light was built in 1849 and rebuilt in 1870. Prior to being damaged by the 1938 hurricane, the island included a pond, gardens, and chicken coops. The hurricane washed away part of the island and destroyed the bell tower, boathouse, and a storehouse.

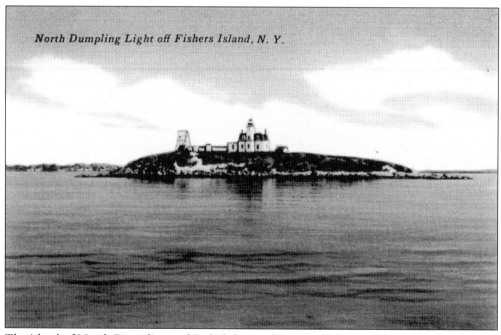

North Dumpling Light off Fishers Island, N. Y.

The island of North Dumpling and its lighthouse, located off the north side of Fishers Island, have been privately owned since 1959, when it was automated. Its present owner is inventor and entrepreneur Dean Kamen, who sponsors robotics competitions at schools on Long Island. The lighthouse has been modified a great deal over the years by its owners.

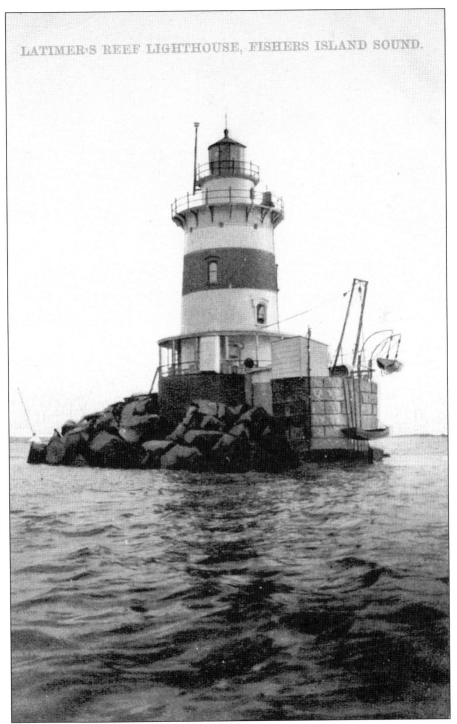

The Latimer Reef Light was established in 1884 on an offshore reef near Fisher's Island. It has often been mistaken as a Connecticut lighthouse. It replaced a lightship at Eel Grass Shoal. The lightship's captain, Charles E. P. Noyes, transferred to the lighthouse and was its keeper for many years.

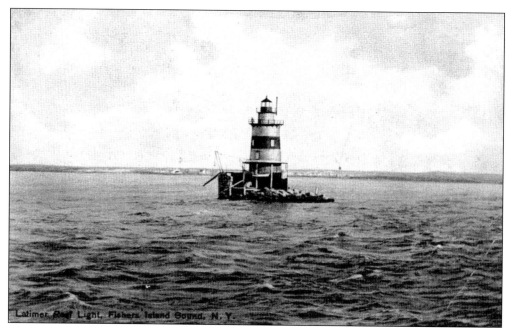

The Latimer Reef tower was one of the early cast-iron towers that spelled the end of stone lighthouse construction in America. Built of curved cast-iron plates that were bolted together on-site, these lighthouses were much more economical to construct. When completed, the tower lacked the current brown stripe. It is still an active light.

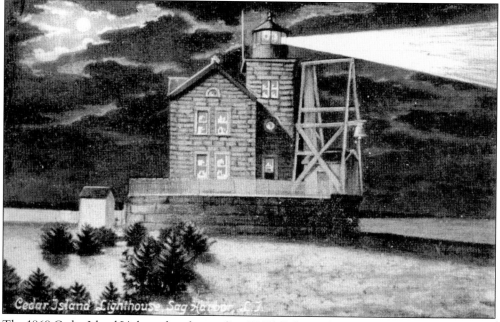

The 1869 Cedar Island Light replaced an earlier (1839) light on the three-acre island. This station served the whaling fleets and other ships of Sag Harbor. The lighthouse was decommissioned in 1934 and remained in private hands for many years. In 1974, the lighthouse was gutted by a fire. In 2003, a restoration effort was begun by the Long Island Chapter of the U.S. Lighthouse Society and the Suffolk County Parks Department.

Nine

LONG ISLAND'S ATLANTIC SHORE

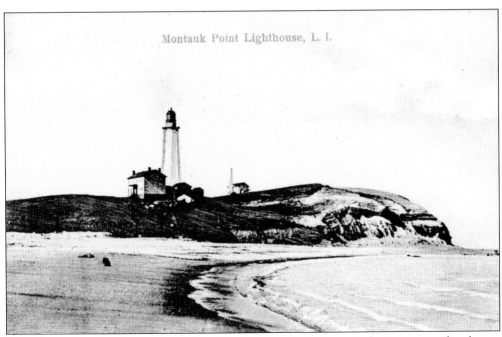

The Montauk Point Light was the first lighthouse built in New York. It was completed, save glass for its lantern room and oil for its lamps, in November 1796. It was not lit, however, until April 1797, as the ship bringing the glass and oil ran aground at Napeague. The oil was stored in the town of Montauk until the replacement glass arrived in the spring.

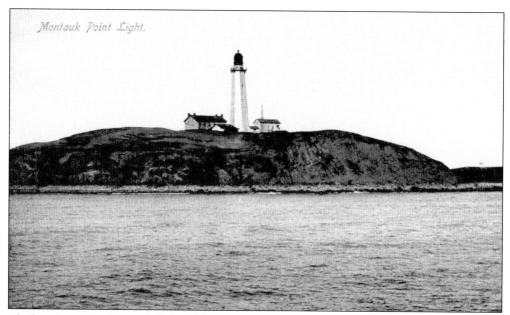

Montauk Point Light.

The location of the Montauk Point Lighthouse was not determined by Pres. George Washington, as local folklore has it. Ezra L'Hommidieu chose the location on Turtle Hill upon the advice of several people who knew the area, including "experienced mariners." Understanding the erosion inherent at the point, they chose a site 297 feet from the shore. This cautious placement would prove wise in later years.

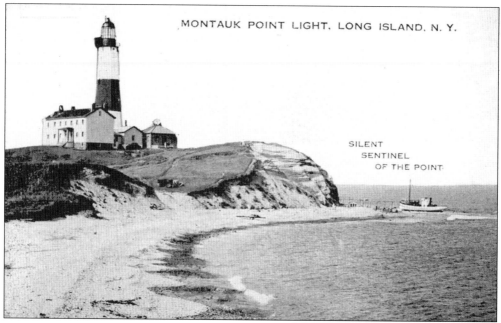

MONTAUK POINT LIGHT, LONG ISLAND, N. Y.

SILENT
SENTINEL
OF THE POINT

The Montauk Point tower's reddish-brown stripe, which is so familiar to Long Islanders, was not put on the tower until 1903. It was at this time that a Third-and-One-Half Order Fresnel lens was installed. This lens, called a bivalve or clamshell type because of its shape, was used in the tower until 1987. It is now on display in a room at the base of the tower.

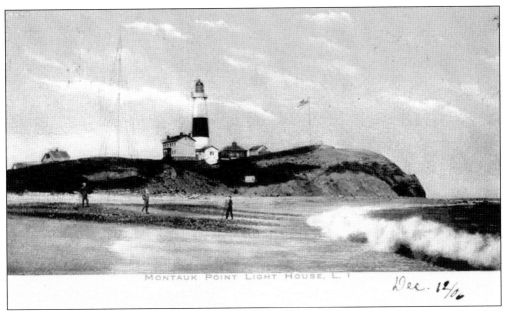

MONTAUK POINT LIGHT HOUSE, L. 1 *Dec. 12/06*

The Montauk Point Light's long existence has given it the opportunity to experience many bits of history, both technological and human. The list of keepers and machinery that have occupied the site is unmatched in New York. As the fourth-oldest operating lighthouse in the United States, it has much information to share, and this is done through an excellent museum in the 1860 keeper's dwelling.

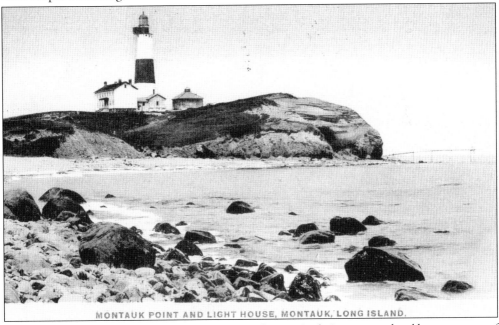

MONTAUK POINT AND LIGHT HOUSE, MONTAUK, LONG ISLAND.

Many Third District keepers spent time at Montauk Point in their careers as head keeper or one of two assistants at the station. These included John F. Anderson, James G. Scott, Jonathan A. Miller, John E. Miller (Jonathan's son), Henry Babcock, Bill Baker, and many others. These keepers were Civil War veterans, retired mariners, immigrants, retired policemen, Coast Guardsmen, and people of other diverse backgrounds. Their stories could fill volumes.

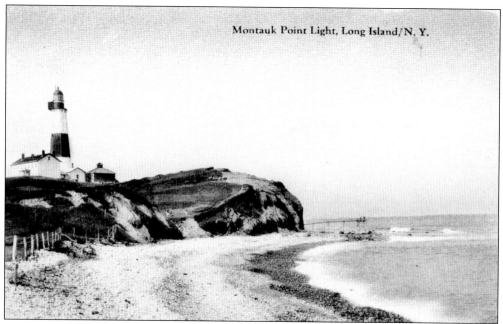

Comparing the shoreline in this postcard to earlier ones shows the effects of erosion on Turtle Hill. This erosion has continued, washing away more than two-thirds of the land between the tower and the sea. A combination of techniques has been used to address the erosion at the site, with specifically placed rocks at the base and Reed Trench Terracing on the bluff.

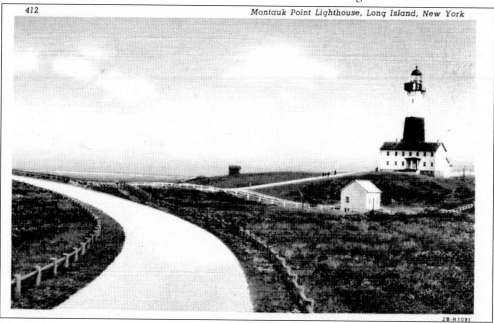

412 *Montauk Point Lighthouse, Long Island, New York*

The building in the foreground of this postcard was first built in 1838 to replace the original Montauk Point keeper's dwelling, which was adjacent to the 1838 location. The current dwelling, at the top of the hill, connected to the tower, was built in 1860 as other improvements were made at the site, including the extension of the tower and installation of a new lantern to house a First Order Fresnel lens.

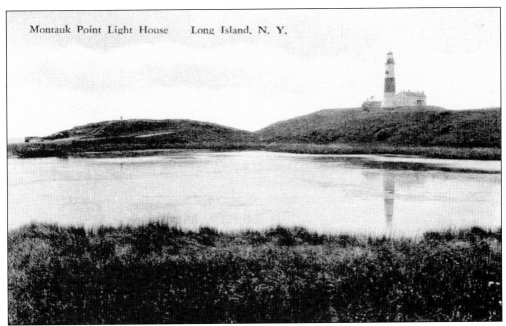

Montauk Point Light House Long Island, N. Y.

Montauk Point's last keepers were removed in 1987. It has since been turned over to the Montauk Historical Society, whose Lighthouse Committee handles the task of caring for New York's most historic lighthouse. Located adjacent to a state park, the Montauk Point Light acts as a destination for a great number of visitors each year who enjoy the site's history, scenery, sea breezes, birds, seals, and other unique attractions.

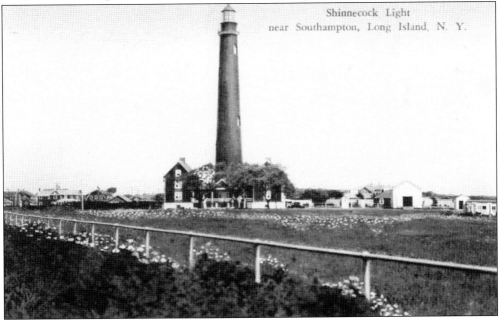

Shinnecock Light
near Southampton, Long Island, N. Y.

When Congress gave administration of the nation's lighthouse system to the newly created Light-House Board in 1852, the board created a list of eight projects that were of the greatest importance in the United States. One of these projects was the building of a "first-class seacoast light-house tower . . . near Great West bay" (Shinnecock Bay) on Long Island's South Shore.

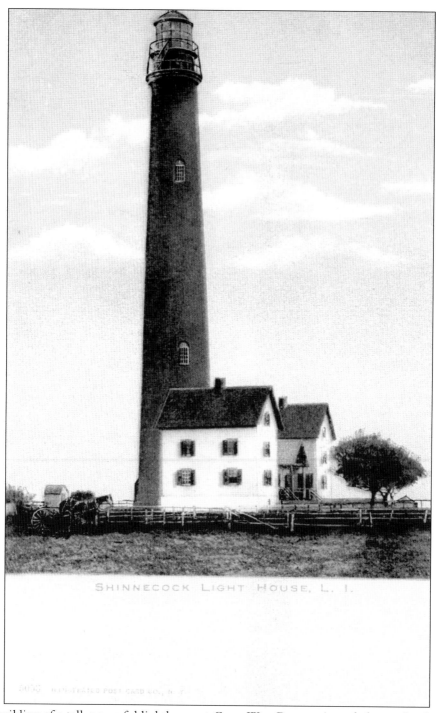

SHINNECOCK LIGHT HOUSE, L. I.

The building of a tall, powerful lighthouse at Great West Bay was intended to make the low, dark, featureless Atlantic shore of Long Island less dangerous to coastal shipping and, especially, transatlantic traffic. The 67-mile stretch of shoreline between the Fire Island and Montauk Point lighthouses included a dangerous 35- to 40-mile stretch in which no light from either existing lighthouse could be seen.

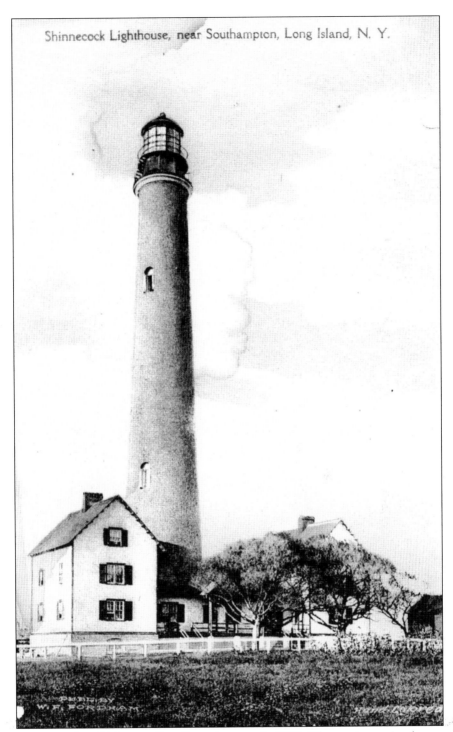

Shinnecock Lighthouse, near Southampton, Long Island, N. Y.

The Great West Bay Light was first lit on January 1, 1858. The engineers in charge of the project were Lieutenants Duane and Morton. These two young engineers would subsequently oversee the building of a new light at Fire Island. At the time of its completion, the 160-foot-tall concrete-washed brick tower was the tallest lighthouse in New York.

Schinnecock Light House, Long Island.

The name of the station was officially changed in October 1893, from Great West Bay to Shinnecock Bay. Local residents, however, have long called it the Ponquogue Light, after Ponquogue Point, upon which the tower was built. The name of the town was also changed, in February 1922, from Good Ground to Hampton Bays. This change was likely intended to capitalize on the growing popularity of the Hamptons.

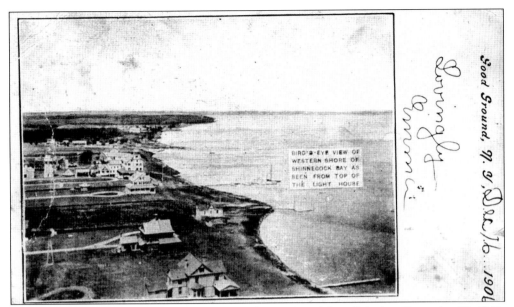

The Shinnecock Bay Light was decommissioned in 1931, and demolished on December 23, 1948. Had it been preserved as a historic site, views such as the above, albeit with many additional buildings, would be possible for thousands of visitors annually. The loss of this lighthouse, and the history of which it was central, underlines the importance of historic preservation efforts around the nation.

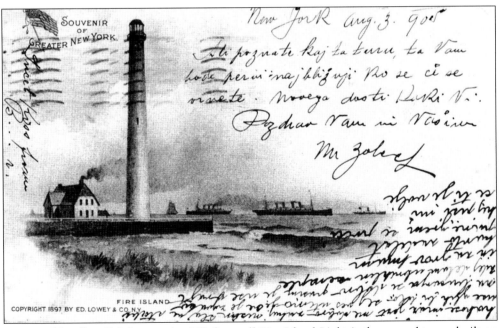

New York's tallest lighthouse, the 168-foot-tall Fire Island Light is the second tower built on Fire Island. The first tower, built in 1827, was too short and poorly built to handle the tough duties and environmental conditions of the site. When the new tower was built in 1858, it was a solid cream color, as seen in this postcard. The above image takes great artistic license, showing ocean liners in the shallow waters of the Great South Bay.

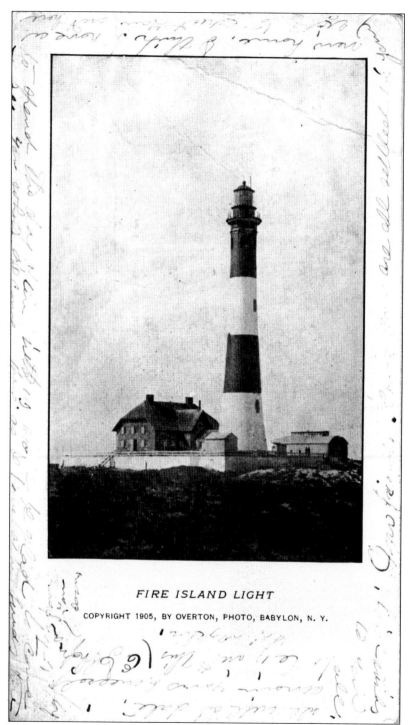

FIRE ISLAND LIGHT

COPYRIGHT 1905, BY OVERTON, PHOTO, BABYLON, N. Y.

Fire Island's lighthouse was given black and white stripes in 1891, a daymark it retains to this day. The tower's hollow walls, designed to allow the tower to breathe, were constructed of more than 800,000 bricks. The tower was then, as at Shinnecock Bay, given a cement wash to help it stand up to the winds and salt spray of the Atlantic Ocean.

124

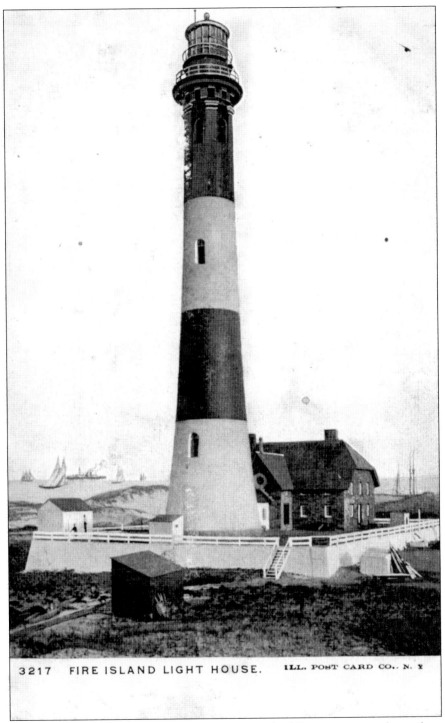

3217 FIRE ISLAND LIGHT HOUSE. ILL. POST CARD CO., N. Y.

As with most land-based light stations, many different outbuildings were erected over the years at Fire Island for storage and other uses. None of the small buildings seen on this postcard, viewed from the north side, currently exist. During its years of being tended by keepers, the site also at times included gardens, man-made ponds, and domestic animals.

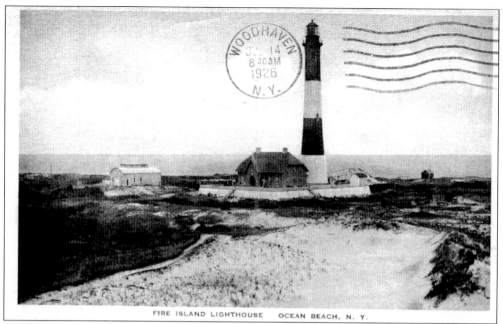

FIRE ISLAND LIGHTHOUSE OCEAN BEACH, N. Y.

In 1894, a generator building was constructed at Fire Island, as there were plans to electrify the light and install a large lens previously on display at the 1893 Columbian Exposition in Chicago. These plans were changed in 1895, and the light would not be electrified until 1939.

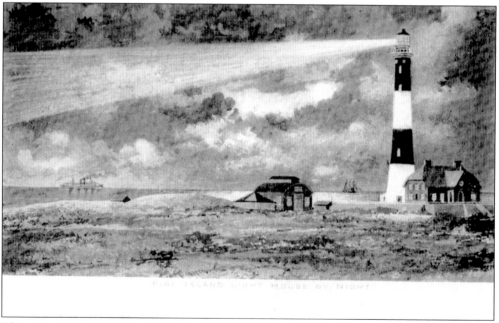

FIRE ISLAND LIGHT HOUSE BY NIGHT

This postcard depicting the Fire Island Light at night also shows the 1894 generator building and adjacent cistern. The cistern was constructed from the base of the 1827 tower. The base of that tower still exists and can be seen, along with an interpretive plaque, from the boardwalk that leads to the lighthouse.